1960S LANCASHIRE STEAM IN COLOUR

George Woods

AMBERLEY

First published 2017

Amberley Publishing
The Hill, Stroud
Gloucestershire, GL5 4EP

www.amberley-books.com

Copyright © George Woods, 2017

The right of George Woods to be identified as
the Author of this work has been asserted in
accordance with the Copyrights, Designs and
Patents Act 1988.

ISBN 978 1 4456 6808 6 (print)
ISBN 978 1 4456 6809 3 (ebook)

British Library Cataloguing in Publication Data.
A catalogue record for this book is available from
the British Library.

Origination by Amberley Publishing.
Printed in the UK.

Introduction

On 15 September 1830, George Stephenson's *Rocket* made its epic journey through Lancashire from Liverpool to Manchester with the first steam-hauled train to carry passengers – an event that would bring dramatic changes to the way we lived. 138 years later, Class 5 45110 made the journey in reverse from Manchester to Liverpool on 11 August 1968, with the special train that brought an end to steam haulage of everyday services on British railways.

The changes that the railways made to the way we travelled and transported goods enabled the growth of the Industrial Age, which had started in the latter half of the eighteenth century, pushing Britain to the forefront of manufacturing and commerce.

The role that Lancashire played in the development of the railways was tremendous, and the next twenty years saw a huge expansion of industry in the north-west of England, while the railway system grew to meet an ever-increasing demand to transport raw materials and finished products. During this time a comprehensive network of lines were built connecting the major manufacturing centres, not only in the north of England, but to many other parts of the country as well.

The mine owners in Yorkshire took advantage of rail transport to deliver coal to the ever expanding industries in Lancashire, many of which depended on steam power, and several Trans Pennine routes opened to take advantage of this traffic.

In 1847 the Lancashire & Yorkshire Railway was formed by amalgamating many small railways, leading to great savings in the cost of operations, and became the major railway in Lancashire and the north-west.

The competitors to the L&Y were the London & North Western Railway, which operated between Liverpool and Leeds via Huddersfield, and the Great Central Railway, which operated suburban services around Manchester and main line services to and from Liverpool, Sheffield and London. They also

carried a large amount of coal traffic from pits in Nottinghamshire and South Yorkshire to a large variety of industries in Lancashire and the north-west.

Locomotive construction in Lancashire became an important industry, with Beyer Peacock's factory in Manchester producing locomotives not only for Britain's railways, but for export around the world. The Great Central's Gorton works and the Lancashire & Yorkshire Railways' works at Horwich, near Bolton, also became famous for their locomotive production and overhaul facilities.

Another famous loco works was the Vulcan Foundry at Newton Le Willows, which exported locomotives worldwide, but in the early 1950s they fell on hard times and in 1955 were taken over by English Electric – a company well known for producing diesel and electric locomotives.

Steam power was the major form of traction until the British Rail modernisation plan started to take effect in the late 1950s; before that just a few suburban routes around Liverpool and Manchester were the only electric lines in the area.

In 1959 the first part of the west coast electrification scheme from London Euston to Liverpool and Manchester was completed. This was the section from Manchester Piccadilly to Crewe that saw a change over from steam to electric traction on both passenger and freight services.

This, of course, resulted in many steam locos becoming redundant; the best ones were used elsewhere, but a lot went for scrap. This process was repeated as more diesel and electric locos were introduced, until in early August 1968 the last steam locos were retired.

In the mid-1960s the realisation that steam was being run down quickly became apparent, and many enthusiasts started to follow steam wherever it could be found. By 1966 steam was confined to the south-western main lines out of Waterloo, which ended in July 1967, and the West Coast Main Line north of Crewe, which would finish at the end of 1967.

By May 1968 the last steam locos were confined to an area bounded by Carnforth in the north, Rose Grove near Burnley in the east, and Lostock Hall near Preston in the south, and these would become the last three depots to house steam.

At this time steam was mostly confined to freight train haulage, but a few passenger trains such as the Belfast Boat Express from Manchester to and from Heysham, and a morning service from Barrow to Lancaster, would last almost to the end. The very last trains were centred on Preston, and were the Liverpool Exchange to Glasgow services, which were steam hauled to and from Liverpool to Preston, and the through coaches to Blackpool North, which were detached from a London Euston to Carlisle service. Another service that lasted almost

to the end was the Barrow to Preston mail train that ran on weekday evenings and was usually hauled by a Class 5.

A major feature of the last years of steam working was the large number of enthusiast special trains that were run nearly every weekend right up to the end of steam by an ever-increasing number of loco preservation societies and other clubs. Some of the proposed trips that were advertised had wildly optimistic itineraries or were to be hauled by locos that had been withdrawn from service, while others ran one tour and were never heard of again.

The established societies still managed to run realistic tours with the cooperation of the railway authorities and many trips were run over lines that were about to close, often hauled by the last examples of locos that were about to become extinct. Some tours were so popular that they became fully booked and a duplicate tour was run on another day.

In the months leading up to 3 August, locomotives became increasingly run-down as maintenance was reduced due to staff shortages and lack of spare parts. The poor quality of coal was another worry as the mines that produced good quality steam coal became fewer; looking back it is amazing that some services managed to keep going, but the steam loco was a tough old machine and they soldiered on in conditions that would have seen their replacements out of action. Working conditions in most loco sheds were very basic compared to what could be found in other industries, and often the tools in use dated from the last century. Additionally, working on steam locos was a dirty job often with unsocial hours, so it was small wonder that very few men were attracted to work in what was then an industry that was being run down.

Despite all the gloom it was not all bad news as some staff were still keen, and the best locos were kept maintained in reasonable condition, plus enthusiasts were allowed to clean locos for use on special trains and last runs. Footplate crews were often able to show that despite the run-down condition of locos, they were still able to give good performances, and some high speeds were achieved, especially on the Liverpool to Preston services and the Belfast Boat Express where speeds in excess of 80 mph were regularly achieved.

In the Railway Modernisation Plan announced in the mid-1950s, it was envisaged that steam would finish sometime in the mid to late 1970s, but the ever-worsening financial situation on the railways was blamed largely on the continuing use of steam locos and it was decided to do away with steam as soon as possible, which resulted in locos that were built as recently as 1960 going to the scrapheap long before the end of their useful life. The last regular steam workings ran on Saturday 3 August with a number of enthusiast specials running the next day, and a final End of Steam special running from Liverpool to Carlisle via Manchester and Settle ran on Sunday 11 August 1968.

The steam loco had served the railways and the country well for nearly 150 years, but as other cleaner and more efficient forms of power to move trains were developed, steam had to give way.

The interest in steam, not just in Britain but around the world, is getting bigger, proved by the ever-growing number of museums and steam-powered heritage railways that attract many thousands of visitors; a steam-powered excursion runs somewhere on the main line in Britain nearly every week, hauled by lovingly restored locos.

It is a strange fact that most locos and carriages running on preserved lines have spent more time in preservation than they did running on the main line system, and that some fifty years after the last steam locos ran in British Railways service, there is still a huge amount of interest in the events of those last few years. This can be seen in the number of books, DVDs and models still being produced.

We do seem to be entering a second railway age, with the National Rail system carrying an ever-increasing number of passengers, and the amazing lineside scenes when *Flying Scotsman* returned to service recently do encourage optimism for the future.

Abbreviations

BR	British Railways
FC	Football Club
GCE	Great Central Enterprises
LCGB	Locomotive Club of Great Britain
LNWR	London North Western Railway
LMS	London Midland Scottish (Railway)
MPD	Motive Power Depot
MRTS	Manchester Rail Travel Society
RCTS	Railway Correspondence and Touring Society
SLS	Stephenson Locomotive Society
WD	War Department

The next eight photos were taken at Stockport Edgeley MPD.

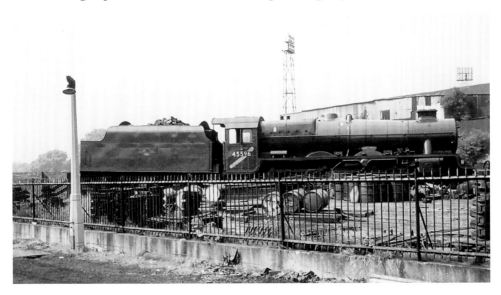

Stored at the back of the shed on 27 August 1966 is Jubilee Class 45596 *Bahamas*, which was one of the few locos of this type to be fitted with a double chimney and exhaust. Withdrawn from service on 23 July 1966, the loco was preserved by the Bahamas Locomotive Society at Dinting, and is currently in full working order. 45596 was built for the LMS in 1935 by the North British Company in Glasgow. In the background can be seen the floodlights at Edgeley Park, home of Stockport County FC.

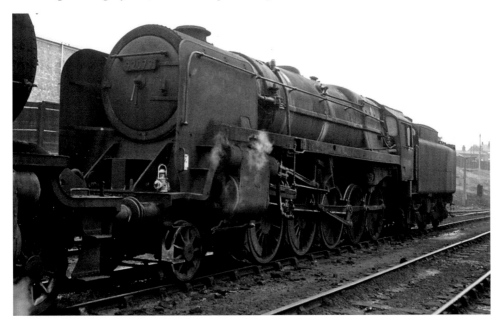

9F 92079 is seen on 27 August 1966. 92079 replaced the famous 58100 in 1956 and was used as the Lickey Incline banker to assist trains up Britain's steepest main line gradient of 1 in 37 over the Lickey hills near Birmingham. The loco was fitted with a headlight and the bolt where this was fixed can be seen at the top of the smokebox. 92079 was built at Crewe in 1956 and withdrawn in November 1967.

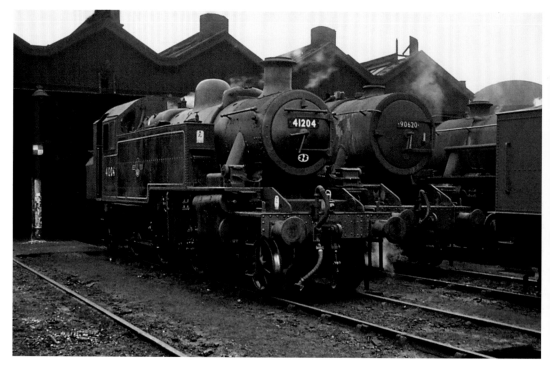

Ex-LMS Class 2T 41204 and WD Class 90620 are waiting for their next duties at Edgeley on 27 August 1966. 41204 was built at Crewe in 1946 and withdrawn in November 1966. 90620 was built in 1944 at Vulcan Foundry and withdrawn in June 1967.

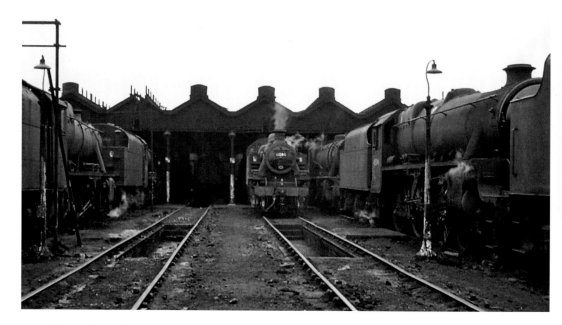

A view taken with 41204 and 45046 prominent, with the usual 8F and Class 5s also visible.

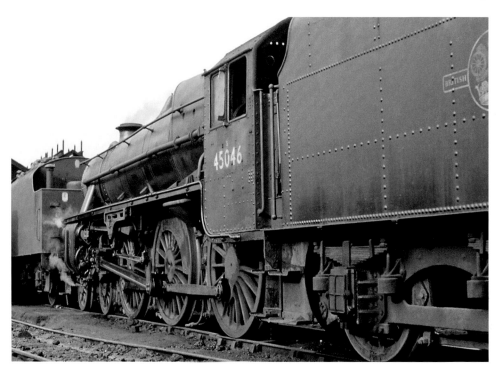

Class 5 45046 is outside the shed on 28 April 1968. 45046 was built in 1935 at Vulcan Foundry and was withdrawn in June 1968.

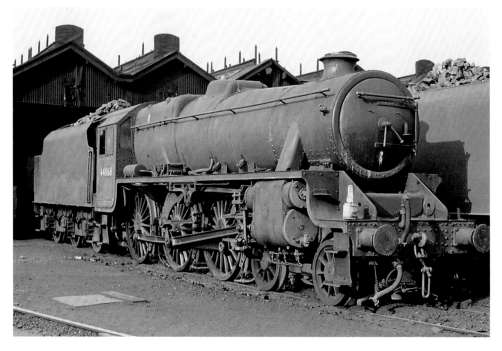

Class 5 44868 is standing outside the main shed building No. 44868 was built at Crewe in 1945 and withdrawn in May 1968.

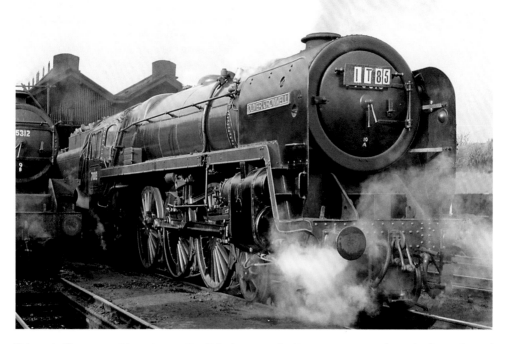

Britannia Class 70013 *Oliver Cromwell* at Edgeley on 28 April 1968, prior to working the Great Central Enterprises Society North West Circular tour. 70013 was built at Crewe in 1951, and on withdrawal from service by BR was preserved as part of the National Collection.

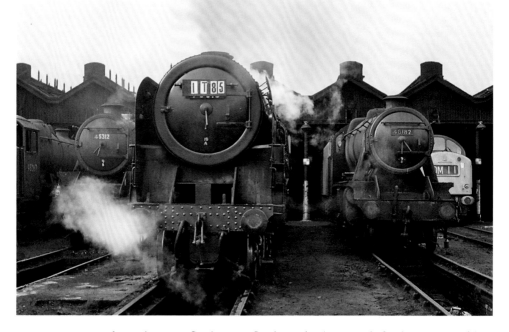

48267, 45312, 70013 and 48182 line up at Stockport on Sunday 28 April 1968, ready for the next turn of duty. It is interesting to see a Class 40 diesel parked among the dirty steam locos, but it won't be for much longer as in early May Stockport shed will close and the diesels will move to the electric depot at nearby Reddish.

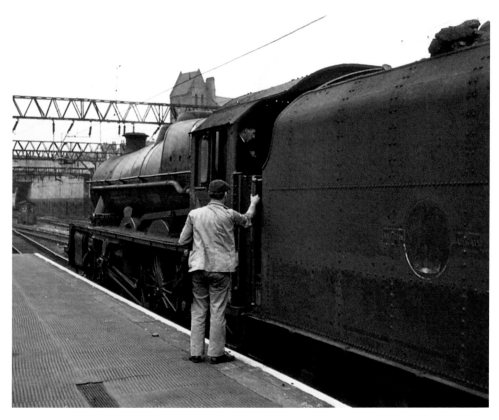

Jubilee Class 45647 *Sturdee* is changing crew during its stop at Stockport Edgeley station on 27 August 1966 with a summer Saturday-only train from Leeds to Llandudno.

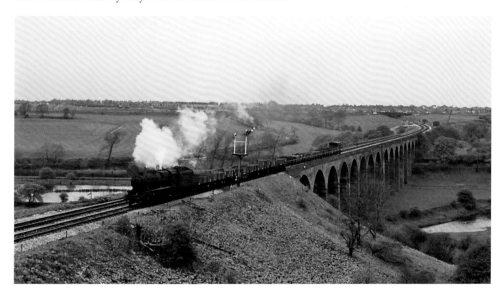

On 20 April 1968, 8F 48373 crosses the seventeen-arch Reddish Vale Viaduct with a southbound freight. The viaduct was built by the Midland Railway in 1875 as part of the Hope Valley route. Legend has it that a witch put a curse on the viaduct, and on anyone who counts the number of arches.

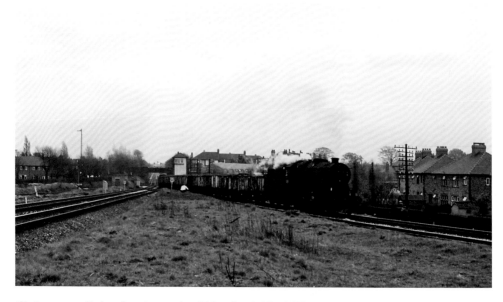

8F 48471 passes Skelton Junction on the old London & North Western route to Warrington and Liverpool, and climbs to cross the Manchester to Altrincham line with a westbound coal train on 20 April 1968. The line to the left of the brick building is a connection to the Altrincham line, the line coming straight ahead goes to Glazebrook Junction, and the CLC route to Warrington.

The next five views were taken at Heaton Mersey MPD on 15 April 1966.

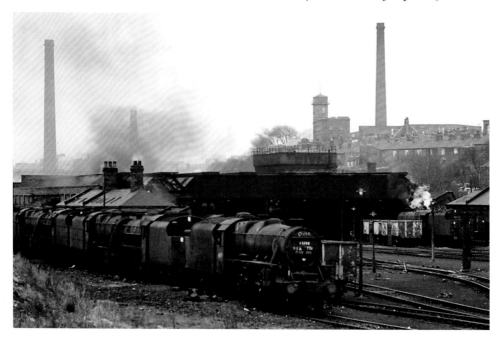

The first photo shows two rows of withdrawn Class 5s and 8Fs on the left and the semi-derelict shed building that still houses working locos. The scene is dominated by the old Victorian factory building and houses, and three large chimneys, which were such a feature of many Lancashire towns.

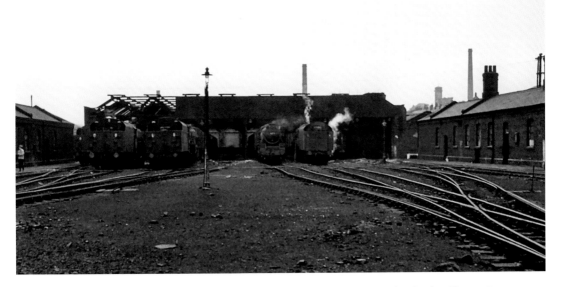

This shot shows the staple diet of ex-LMS Class 5s and 8F locos, which were used on local and longer distance freight trains. The eight-road shed is typical of many at the end of steam, being in a very run-down condition.

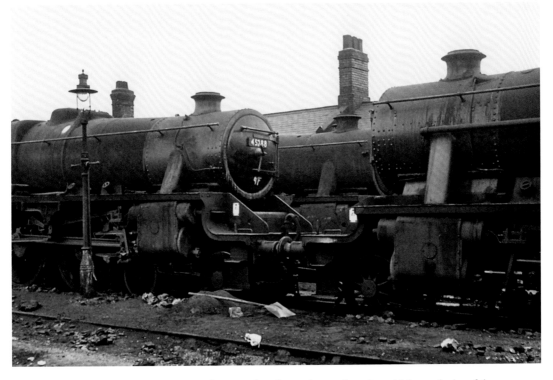

Class 5 45288 and two other locos stand among the ashes and general squalor, which was the lot of the men who worked at sheds like these at the end of steam traction on BR. Note the gas lamps that were still in use.

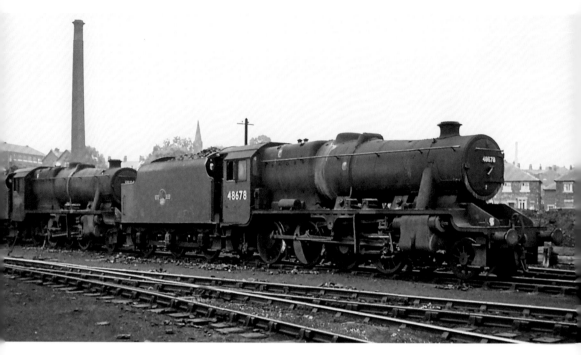

8F 48678 and a sister engine stand in the shed yard ready for duty on Monday morning. In the background a handsome mill chimney and its factory dominate the scene.

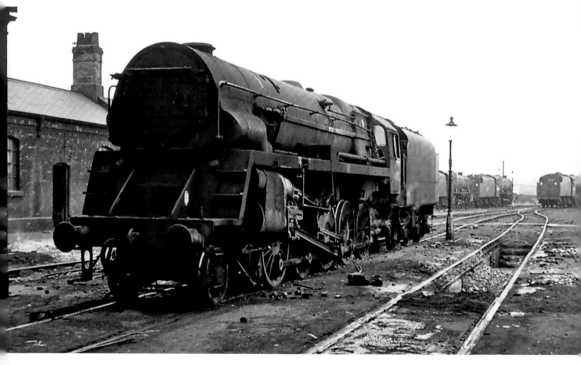

9F 92022, which was one of ten built with an Italian Franco Crosti boiler, is a visitor from Speke Junction. 92022 was built at Crewe in 1955 and scrapped in April 1968.

The next six pictures show freight trains passing through the pastoral scenes that are part of Reddish Vale Country Park around Brinnington. The line was on the Cheshire Lines Committee route from Stockport Tiviot Dale up to Woodley Junction. The M60 motorway that was built after the railway closed to all traffic in 1987 runs through the area, and part of the old trackbed has now been converted to a foot/cycle path.

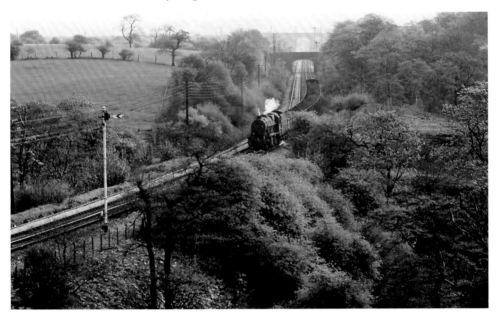

8F 48546 heads cautiously down grade towards Stockport Tiviot Dale on 30 April 1968 with a heavy coal train heading for a Lancashire power station.

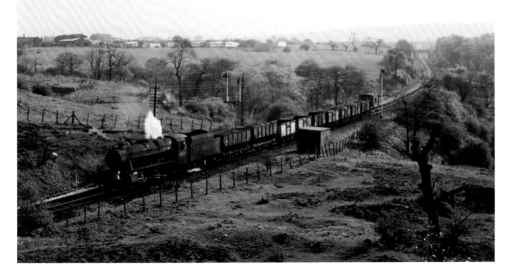

8F 48722 heads a short coal train towards Tiviot Dale on 30 April 1968.

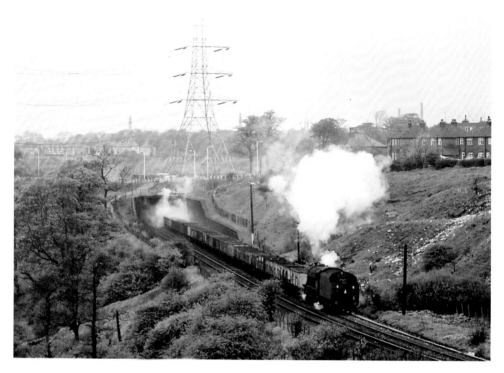

8F 48026, running tender first, works hard upgrade out of Brinnington tunnel with coal empties heading for the yards at Godley Junction on 4 May 1968.

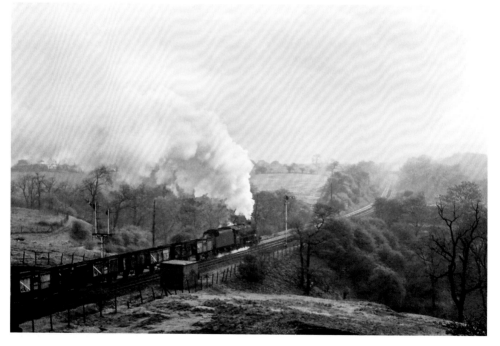

Class 5 45392 works another train of coal empties up the hill for Godley Junction on a misty 30 April 1968. These will head east over the Woodhead route to collieries in Yorkshire.

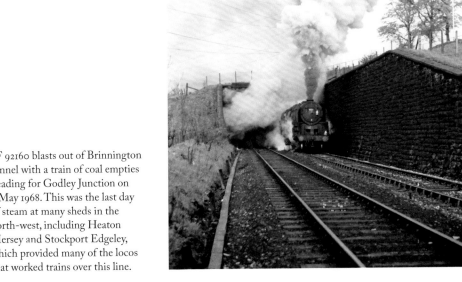

9F 92160 blasts out of Brinnington tunnel with a train of coal empties heading for Godley Junction on 4 May 1968. This was the last day of steam at many sheds in the north-west, including Heaton Mersey and Stockport Edgeley, which provided many of the locos that worked trains over this line.

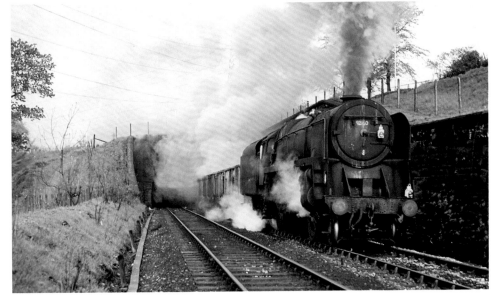

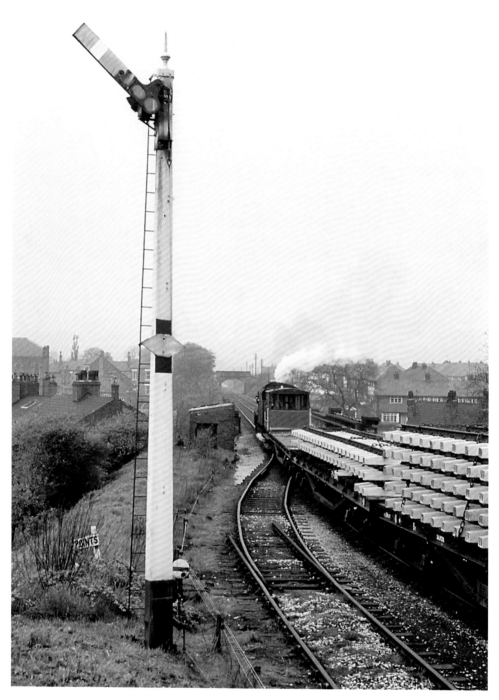

An 8F has just passed Woodley Junction on 4 May 1968 and heads cautiously down the gradient towards Stockport Tiviot Dale with a heavy train of new track panels.

The next six shots are taken around Aperthorne Junction on Saturday 4 May 1968, which was the last day of steam working from Heaton Mersey and several other Lancashire sheds.

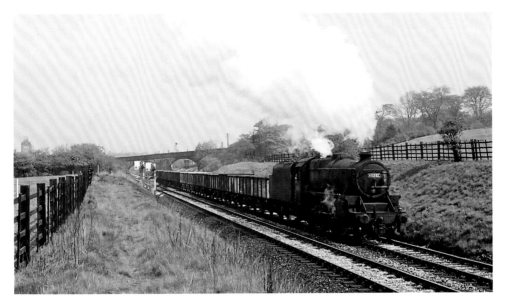

Class 5 45282 runs through the junction on the line from Guide Bridge, with a westbound train of iron ore wagons.

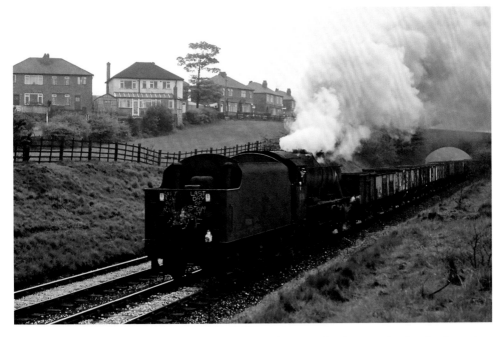

8F 48660, running tender first, approaches the junction with a train of coal empties heading for the yards at Godley Junction. The loco wears a wreath to mark the end of steam traction at Heaton Mersey Shed, which along with several others was closed that weekend.

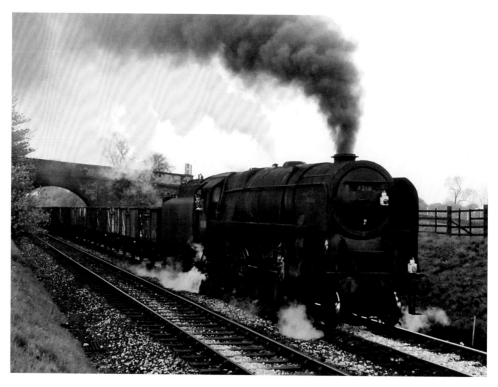

Another train of coal empties heads for Godley Junction behind 9F 92118, which by this time was one of the last 9Fs in service.

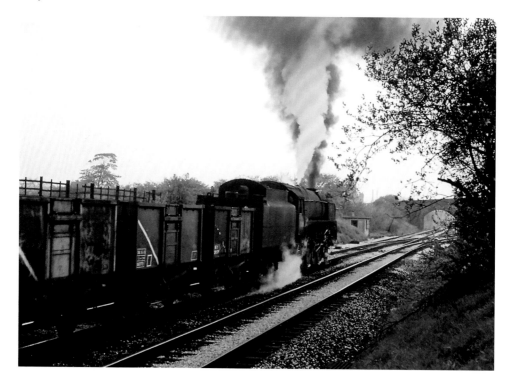

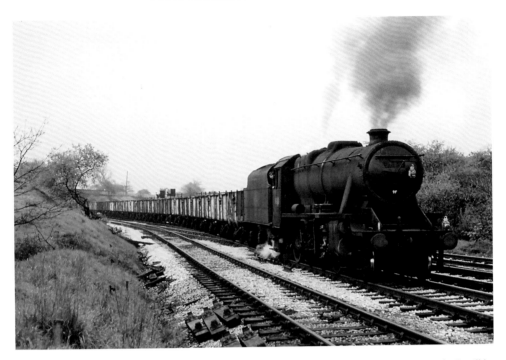

8F 48356 passes over the junction and takes the line to Godley Junction with more coal empties, which will be heading for the Yorkshire collieries for another load.

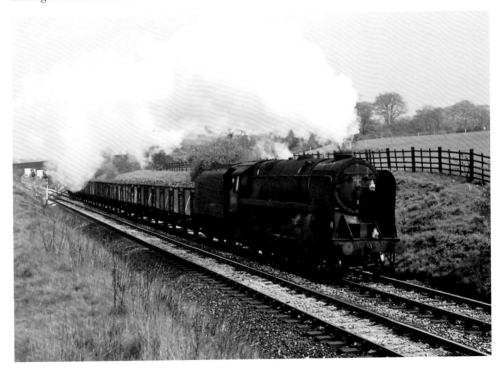

9F 92160 heads back from Godley Junction with a loaded coal train that is bound for one of the many power stations in the Manchester area.

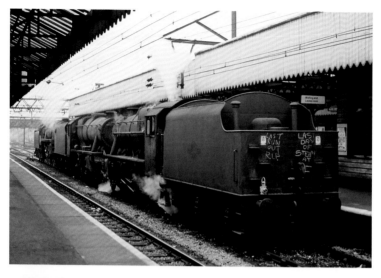

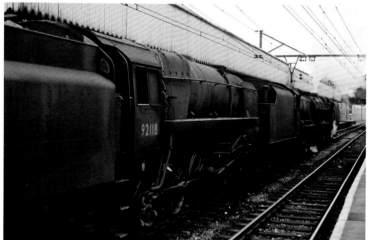

Three views of 48356, 48319 and 92118 at Guide Bridge station on 4 May 1968. These three locos were on their way from Heaton Mersey Shed to Newton Heath Shed, from where 92118 went on to Carnforth and worked until May 1968. 48319 finished up at Bolton and was withdrawn at the end of June, and 48356 was withdrawn from Newton Heath, also at the end of June.

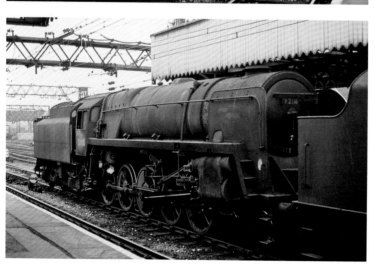

The next three views were taken on the last day of steam traction on BR 4 August 1968 at Patricroft MPD.

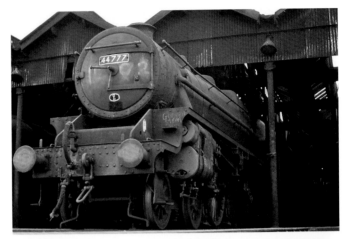

Class 5 44777, which had been withdrawn in June 1968, and would be cut up at Cohens of Kettering.

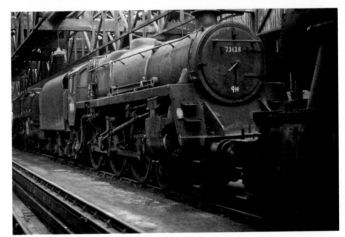

Standard Class 5 73138 is seen inside the shed among other locos waiting to make their last journey to the scrap yard. 73138 will be cut up at Cashmore's Great Bridge yard.

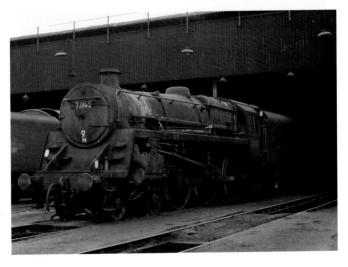

Standard Class 5 73143 seen here is also waiting for a tow to the scrapyard, in this case also Cashmore's of Great Bridge. Both 73138 and 73143 were equipped with Capprotti valve gear.

The next eleven photos were taken at Newton Heath MPD on Sunday 16 October 1966. At this time Newton Heath remained a busy shed with quite a few passenger workings still handled by steam, along with freight trains, some of which worked over the Pennine routes to the east.

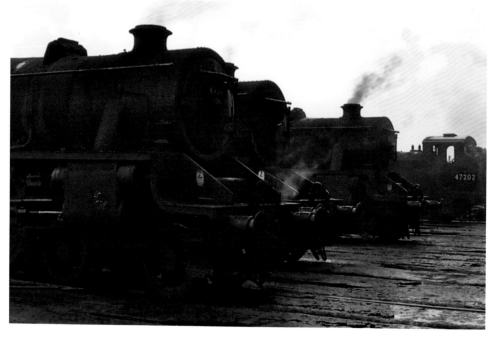

In these two views, three unidentified Class 5s are lined up ready for their next duties.

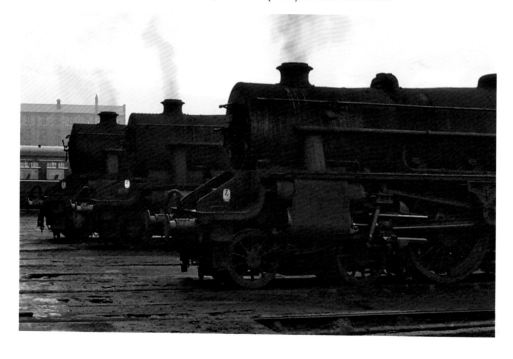

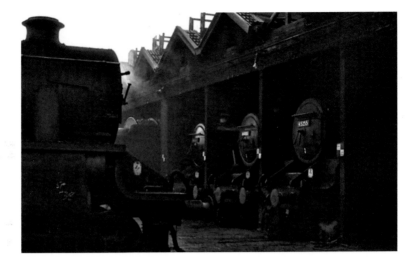

This photo shows four Class 5s, including 44803 and 45255 all in light steam, ready to work trains on Monday morning.

Two photos of ex-Midland Railway tank engine Class 3F 47202, which was based at Kentish Town in London for many years and is still fitted with condensing gear. This was used when working cross-London freight trains through the widened lines on the Underground. 47202 was built by Vulcan Foundry in 1899 and was withdrawn from service shortly after this photo was taken.

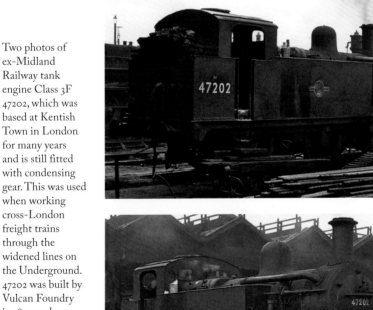

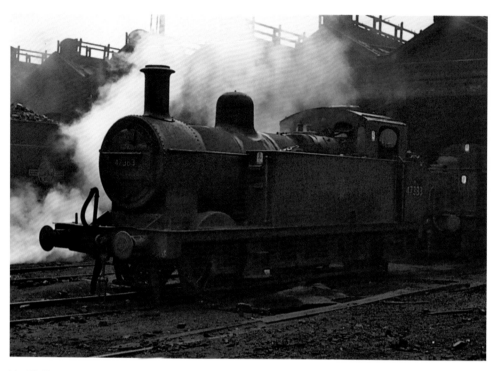

Ex-LMS 3F 47383 was built by Vulcan Foundry in 1926 and, since withdrawal in 1967, it has been preserved on the Severn Valley Railway.

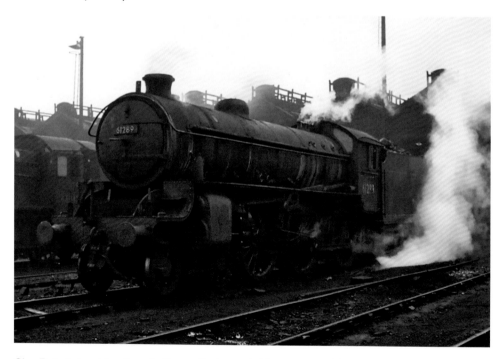

Class B1 61289 is a visitor from the Eastern Region, probably arriving on a Trans Pennine parcels train as it was based in Hull at this time. Built by North British in 1948, it was withdrawn in June 1967.

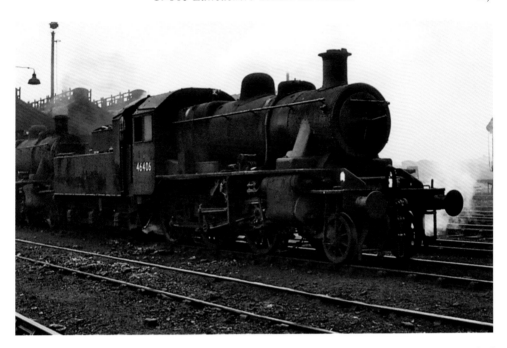

Ex-LMS Ivatt 2MT 46406 stands at the eastern end of the shed with a sister engine in the gathering murk of an October afternoon. Built at Crewe in 1946, the loco would be withdrawn in early 1967.

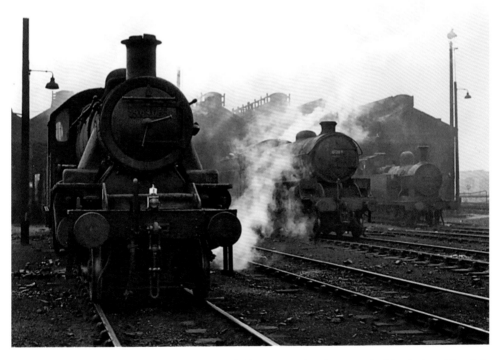

Ex-LMS Ivatt 2MT 46406, B1 61289 and Ex-LMS 3F 47383 stand at the east end of the shed awaiting their next duties.

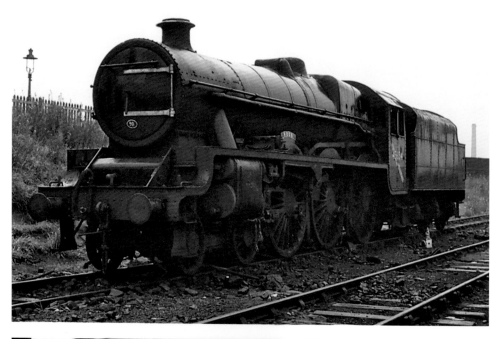

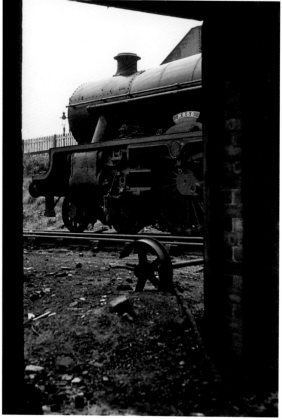

Jubilee Class 45654 *Hood* is in a derelict state, waiting to make its last journey to the scrapyard, having given thirty-one years' service since it was built at Crewe in 1935.

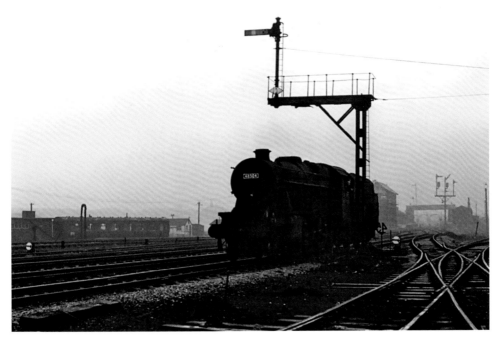

Above: 8F 48504 is passing Newton Heath MPD in the gathering gloom from the Middleton Junction direction on 16 October 1966.

Right: Jubilee Class 45562 *Alberta* climbs the gradient out of Manchester Victoria station up to Miles Platting with a Llandudno–Leeds train on a murky Sunday 16 October 1966. The exhaust of 46437, which is pushing hard at the back, can be seen above the DMU. *Alberta* was a favourite with enthusiasts at the time and efforts were made to preserve her, but these unfortunately failed. Built by North British in Glasgow in 1935, she was to be the last Jubilee in service, and would be withdrawn in November 1967 to be cut up at Cashmore's Great Bridge yard.

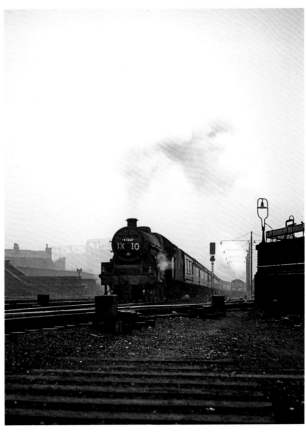

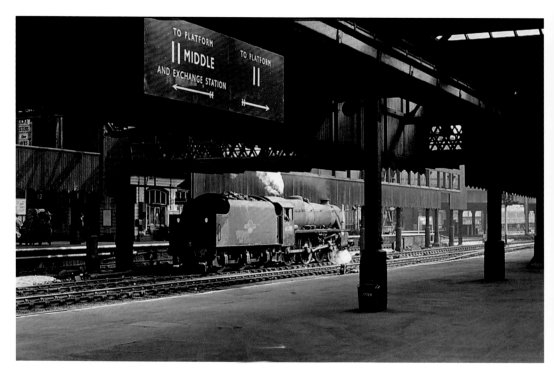

A quiet Sunday morning scene at Manchester Victoria station on 16 June 1968 with the Miles Platting bank engine Class 5 45206 taking things easy.

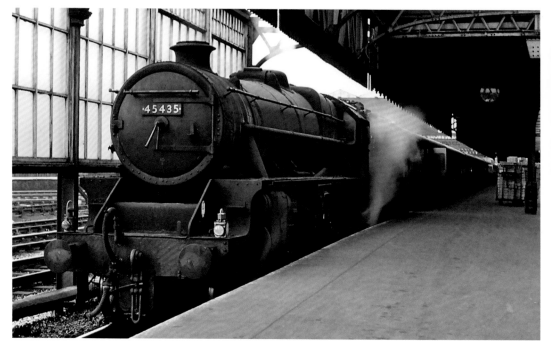

Class 5 45435 has express passenger headlamps as it stands at Manchester Exchange station with the 20.45 Belfast Boat Express for Heysham. Taken on 28 April 1968.

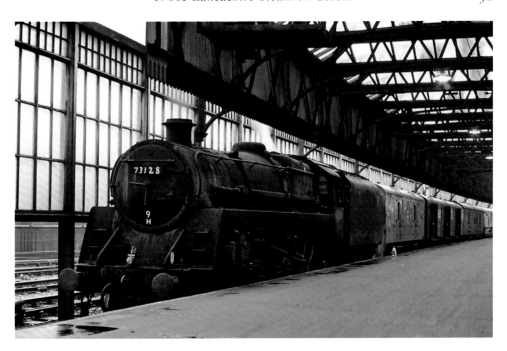

Standard Class 5 73128 stands at Manchester Exchange station on 28 April 1968 with a parcels train. It is standing at platform 3, which ran the length of both Exchange and Victoria stations, and at 2,914 feet was the longest platform in Great Britain. Exchange closed in 1969 but Victoria remains open and has been recently rebuilt.

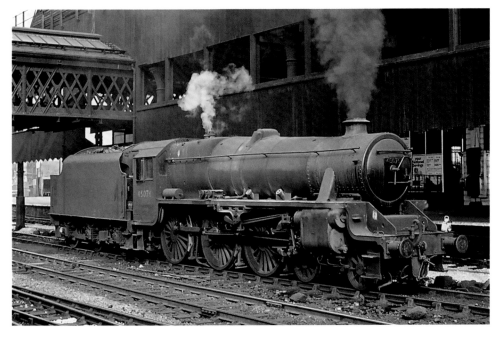

Class 5 45076 is the Miles Platting banker in May 1968, and waits for its next job at Manchester Victoria station. 45076 was built at Vulcan Foundry in 1935 and lasted almost until the end of steam, being withdrawn in June 1968.

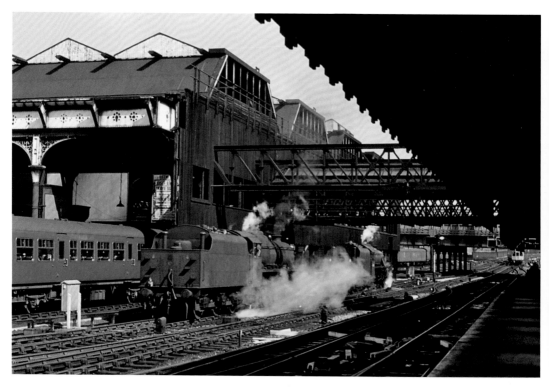

Two Class 5s, 45411 and 44809, wait for the call to duty at Manchester Victoria station in May 1968. Alterations to the station were carried out in the 1990s but were unpopular with the public and a more sympathetic rebuilding was completed in 2015, including a major interchange with the Manchester tram system.

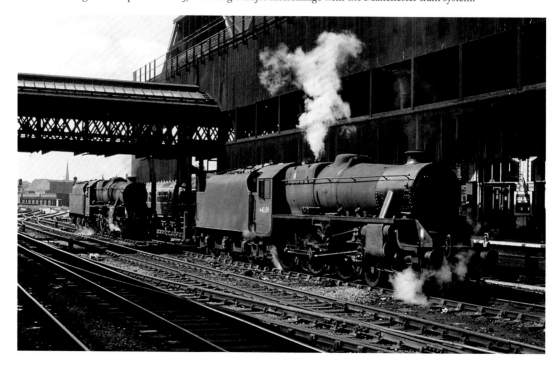

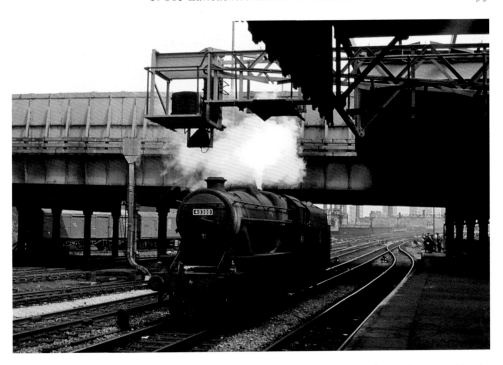

8F 48380 drifts through Manchester Victoria station light engine in May 1968 having been noted by the cluster of trainspotters at the end of the platform. The lines going off to the left are to Rochdale, and straight ahead is the Trans Pennine route via the Calder Valley.

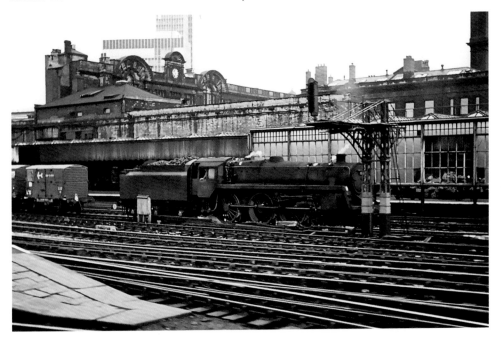

Standard Class 5 73035 stands at Manchester/Victoria Exchange station on 25 June 1966. Behind the loco platform 3 can be seen, which connected the two stations and was the longest platform in Great Britain at 2,914 feet.

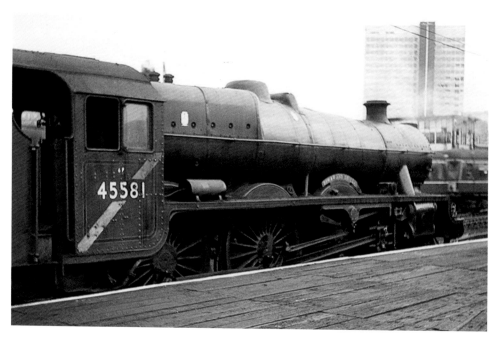

Jubilee 45581 *Bihar & Orissa* stands at Victoria station having just taken over the Warwickshire Railway Society Aberdonian Railtour from Merchant Navy Class 35026 *Lamport & Holt Line* on 25 June 1966.

45581 heads the Aberdonian through the wonderfully named Moses Gate station, which is just south of Bolton. This tour was run over three days from London Waterloo to Aberdeen and return. The train consisted of a rake of Southern green coaches and the cost of well over a thousand miles of travel behind nine different locos was ten guineas. A berth in a sleeper was extra.

Class 5 44874 roars past Clifton Junction into the last of the sunset on 3 May 1968 with the Belfast Boat Express, heading for Heysham and the connecting ship across the Irish Sea. On the left the cooling towers of Kearsley Power Station can be seen steaming away.

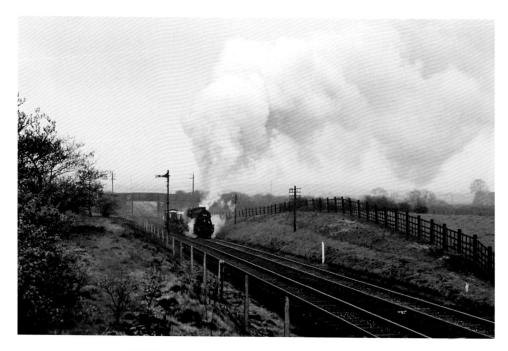

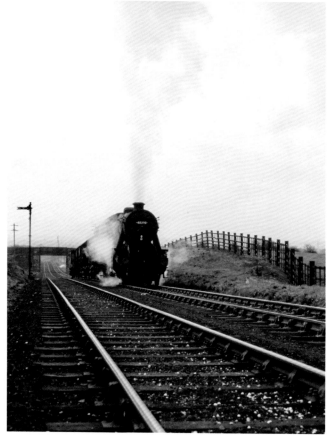

The first two of the next four pictures show 8F 48390 climbing to Chequerbent on the morning of 3 May 1968 with six wagon-loads of sand, heading for the concrete works at Pendlebury Fold near Hulton Sidings. The train is ascending the incline on the Bolton & Leigh Railway, which opened to freight in 1828 and became the first public railway in Lancashire, eventually running from Bolton Great Moor Street station to Kenyon Junction. The steepest gradient between Atherton Bag Lane station and Chequerbent station was supposed to be 1 in 30, but mining subsidence severely affected the track and a section was reckoned to be about 1 in 18. Passenger traffic over this line ceased in 1954, and final closure came in 1969. The other two pictures show 48390 returning down grade to collect some more hoppers that it worked up the hill in the afternoon. The locos for these trains were provided by Patricroft shed.

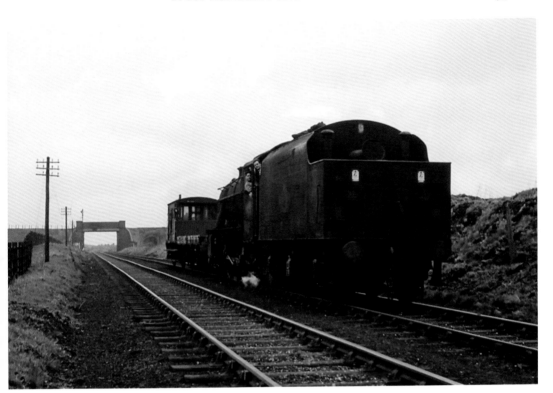

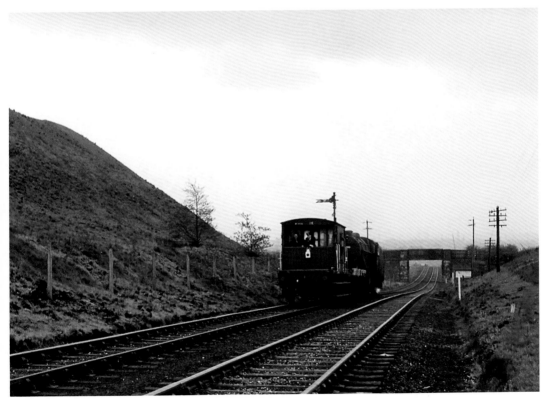

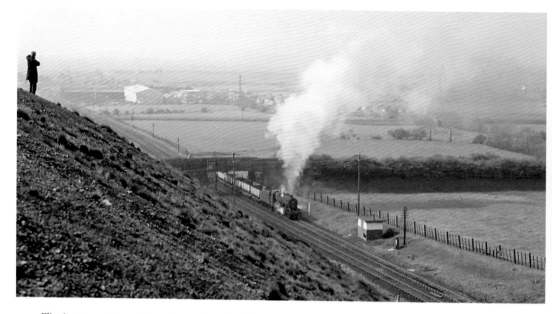

The last two pictures show 48390, taken by a friend of mine after the sun came out, of the afternoon train ascending the gradient, this time taken from an old mining tip. The site of Atherton Bag Lane station is just out of the picture in the top left corner. The author is on the left in the first shot taking cine film. Shortly after, two policemen were seen scrambling up the tip, wanting to know what we were doing. They had received a phone call about suspicious activity and thought we might be burying a safe or something, but after playing back a recording of the 8F, and the lack of any digging implements, they were convinced that we were innocent of any wrongdoing, just slightly crazy.

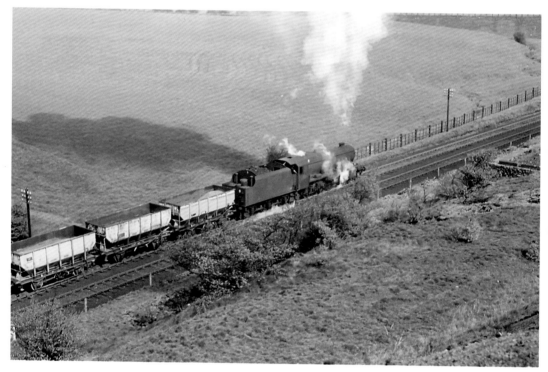

The first of seven pictures taken at Bolton MPD on 28 April 1968 is this view taken looking up Back Dobie Street towards the shed entrance. Street View shows that Back Dobie Street and the buildings in the picture still exist, but the shed entrance is now a road leading into a new housing estate that occupies the site of Bolton MPD.

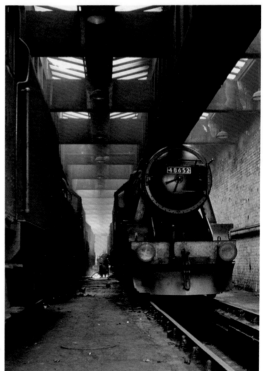

8F 48652 stands inside the shed. This loco was built at Eastleigh in 1943 and lasted almost to the end of steam, being withdrawn at the end of June 1968.

Left: Two fitters are cutting the connecting rods off of a withdrawn 8F to enable it to be towed away for scrap. With the ever-quickening pace of loco withdrawals at Bolton, these two men would be kept occupied until the shed closed later in a few months' time.

Below: In this view the red buffer beam of 8F 48773 stands out like a beacon among the 8Fs and Class 5s. 48773 was built by North British in 1940 and was one of three 8Fs that returned from the Middle East in 1952. On withdrawal in 1968 it was preserved on the Severn Valley Railway.

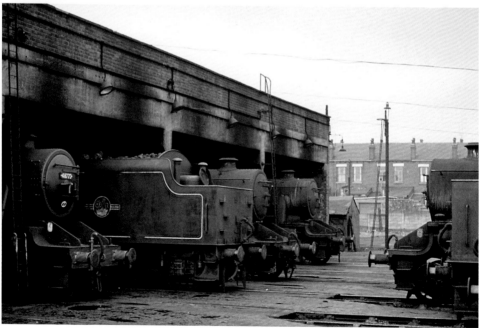

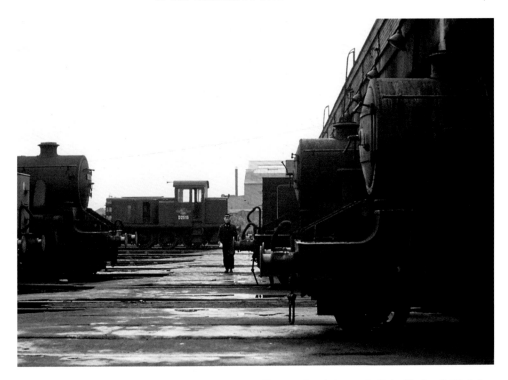

It was not only steam that was going for scrap in 1968; D2515, a diesel shunter built by Hudswell Clark, has its rods off and looks like it is waiting to make the final journey. An assortment of Class 5s and 8Fs complete the picture.

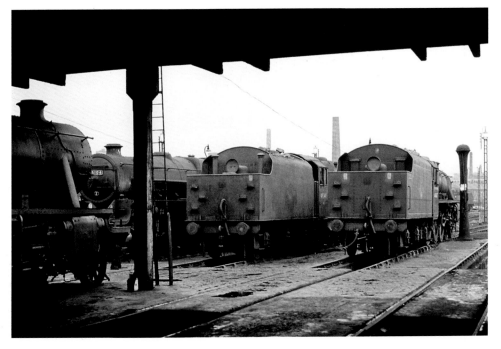

8F 48773, Class 5 45104, 8F 48340 and Class 5 44947 wait for their fires to be lit for duty on Monday morning.

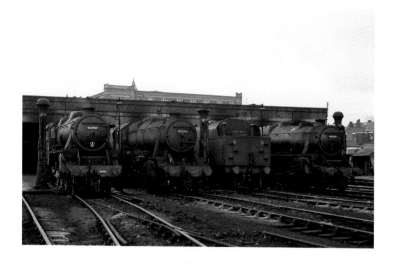

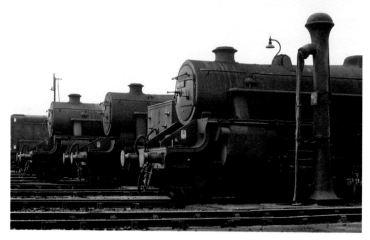

44947, 48340 and 44929 can be seen here. 44947 was built at Horwich in 1946 and was scrapped at Cohens of Kettering in late 1968. 48340 was built at Horwich in 1944 and lasted until the end of steam on 3 August 1968. 44929 was built at Crewe in 1946 and also met its end at Cohens of Kettering.

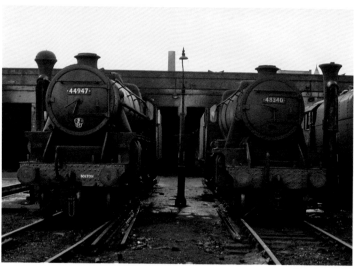

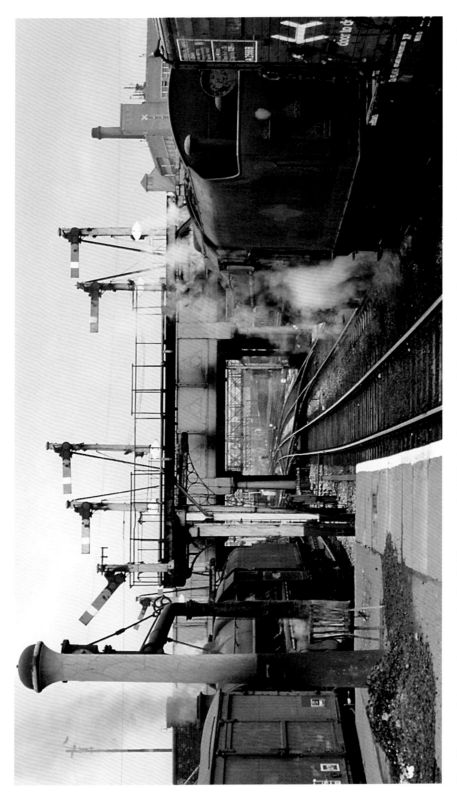

Two Class 5s at Bolton station on 29 April 1968. The one on the left is shunting vans to the large goods warehouse next to the station, while the one on the right is waiting to depart with a freight towards Manchester. Although British Railways was carrying less freight every year at this time, the lines of wagons in the distance and the amount of trains we saw suggested plenty of traffic was still available in this area.

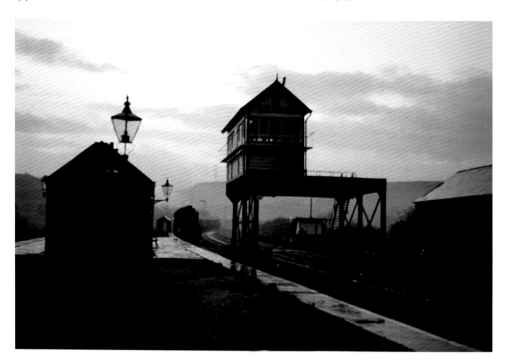

8F 48247 heads towards Bolton through Entwistle station on 29 April 1968 at sunset with a freight train from the Blackburn direction. The lines through here have been reduced to a single track, a sign of the times, as very little freight now passes this way, with the Manchester to Blackburn passenger service being the main user.

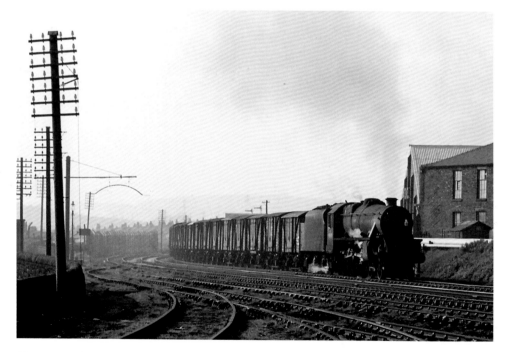

Class 5 45420 slogs up the hill approaching Darwen station, towards the summit of the line at Sough Tunnel on 29 April 1968 with a freight heading towards Bolton.

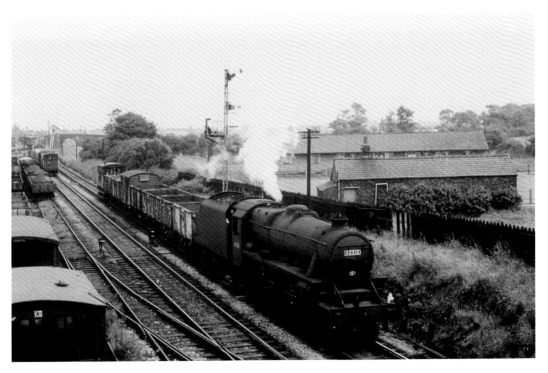

Two pictures of freight trains heading towards Preston through Lostock Hall station on 16 July 1968. The first is headed by Class 5 45318, which was built by Armstrong Whitworth in 1937, and the second, Class 5 44806, was built at Derby in 1944.

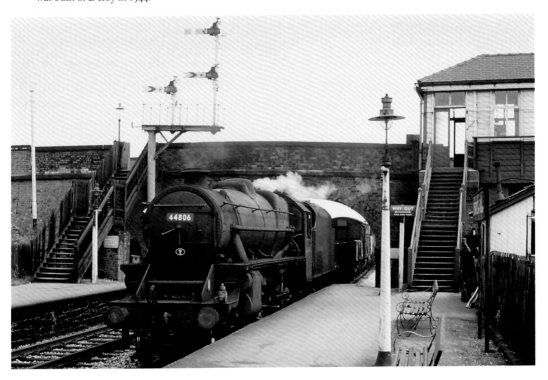

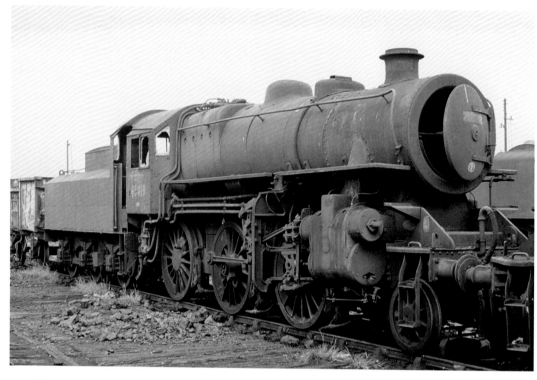

Two Ivatt Class 4s, 43019 and 43027, at Lostock Hall MPD on 16 July 1968, withdrawn from service and waiting to be towed away to the Arnott Young yard at Dinsdale for scrapping.

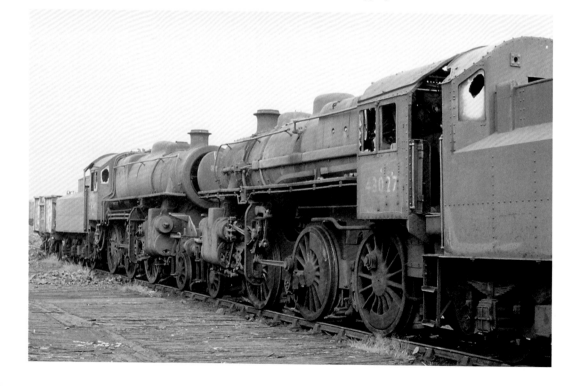

The following four pictures were taken at Lostock Hall MPD on the afternoon of Saturday 3 August, which was the last day of normal operations with steam locomotives on British Railways.

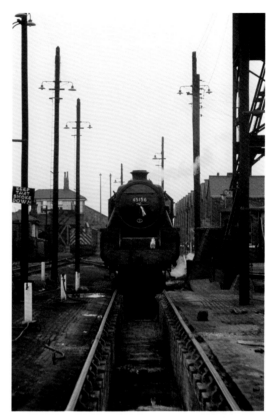

Right: Class 5 45156 *Ayrshire Yeomanry*, seen here on the servicing road, was one of only four Class 5s to be named and worked one of the specials the next day. It was scrapped in December 1968.

Below: 8F 48493 has made its last journey and awaits its fate. Class 5 45305 will be preserved by Alfred Draper in Hull, and 45212 will work the 20.45 Preston to Blackpool train, which will be the second-to-last steam-hauled passenger train on British railways. 45212 will go into preservation on the Keighley & Worth Valley Railway.

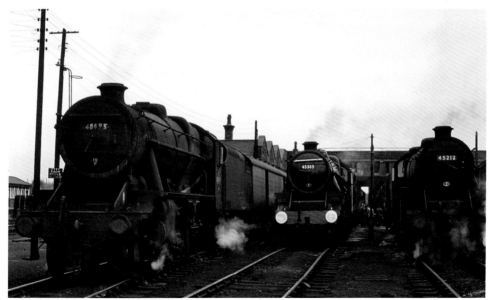

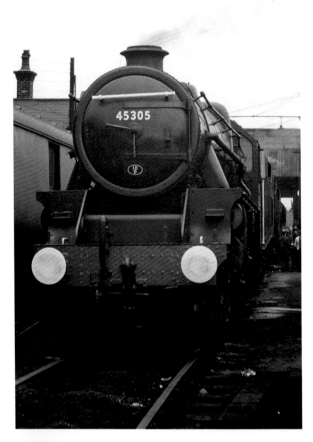

Left: Class 5 45305 has been given a polish and is ready to work one of the next day's specials.

Below: Enthusiasts have chalked Goodbye slogans on Class 5 44874, which will also be working one of the next day's specials, but after it is withdrawn it will go for scrap.

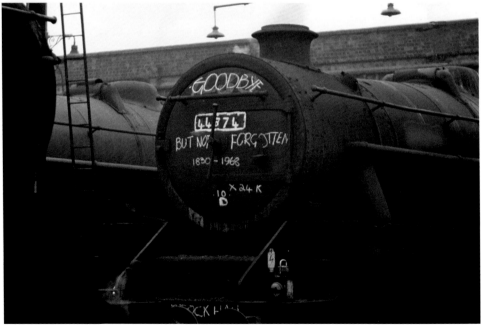

Two views of the lines of locos waiting to be towed away to various scrapyards, taken at Lostock Hall MPD on 3 August 1968. In the background the large coaling tower stands above everything else, and the concrete structure will need explosives to demolish it.

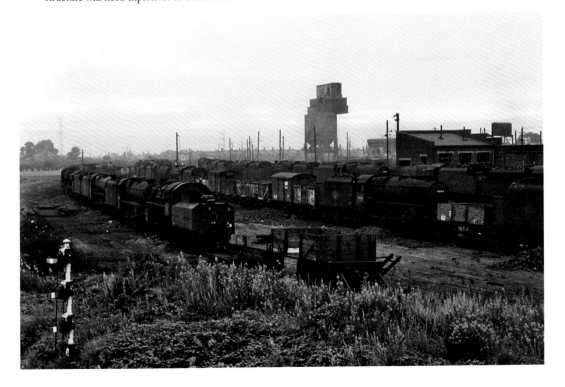

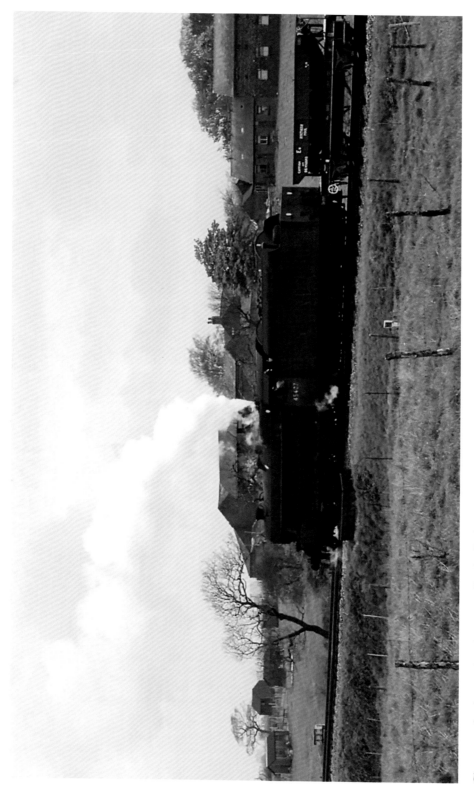

Class 5 45407 heads an engineer's train near Bamber Bridge Junction on 29 April 1968.

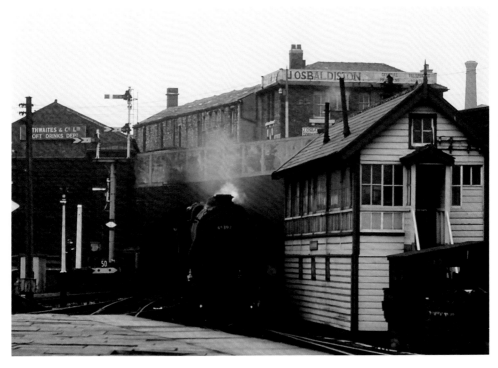

Two views taken at Blackburn on 1 May 1968 of Class 5 45397 with the evening Colne–Preston parcels train. The first shows it emerging from the tunnel to the east of Blackburn station and the second standing at the platform waiting for departure. 45397 was built at Armstrong Whitworth in 1937 and was scrapped in December 1968.

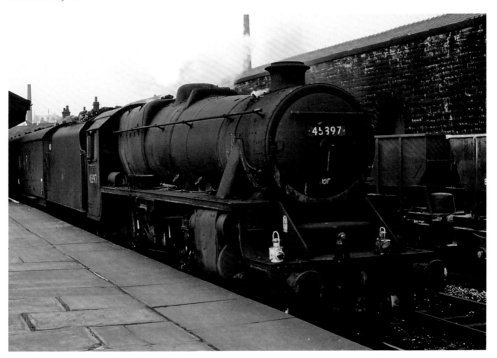

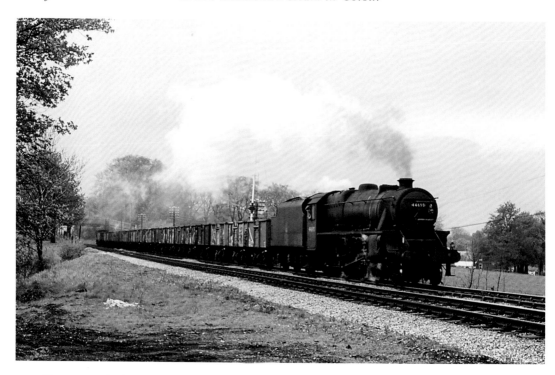

Class 5 44690 climbs towards Hoghton on 29 April 1968 with coal empties, heading for the Yorkshire collieries.

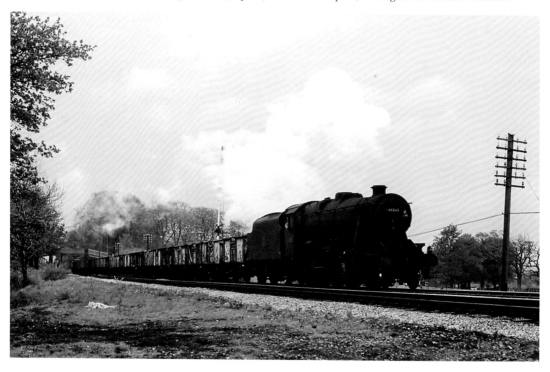

8F 48062 heads another train of coal empties eastwards towards Hoghton on the Blackburn to Preston line on 29 April 1968.

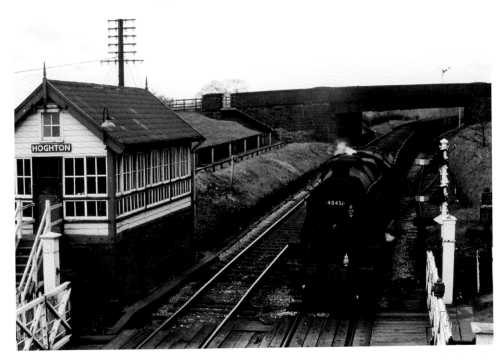

8F 48451 rolls downhill through Hoghton with a coal train heading for Wyre Dock near Fleetwood, where the coal will be loaded on board a ship for Northern Ireland.

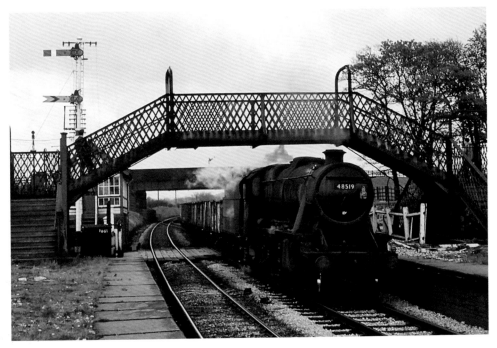

Another 8F 48519 passes the remains of Hoghton station, which closed in 1960, with a westbound coal train. Taken on 29 April 1968.

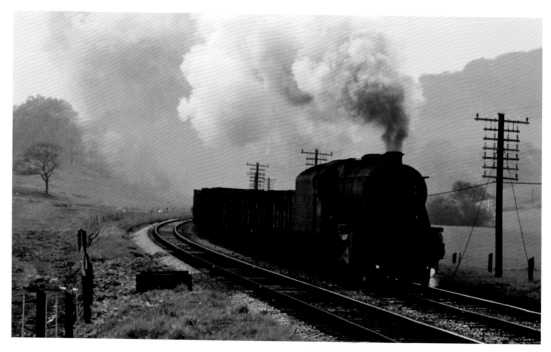

8F 48247 climbs past Pleasington golf course with eastbound coal empties on 2 May 1968.

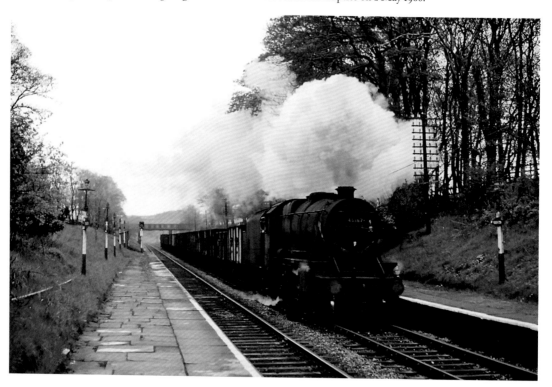

8F 48167 climbs through the pleasant surroundings of Pleasington station with an eastbound train of coal empties from Wyre Dock to the Yorkshire coalfield on 3 May 1968.

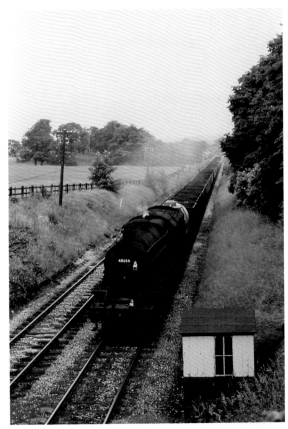

Right: 8F 48666 has an ICI chemical tanker at the head of its westbound coal train as it approaches Pleasington station on 3 May 1968.

Below: Class 5 44806 heads towards its home depot at Lostock Hall and passes through Pleasington station on 3 May 1968.

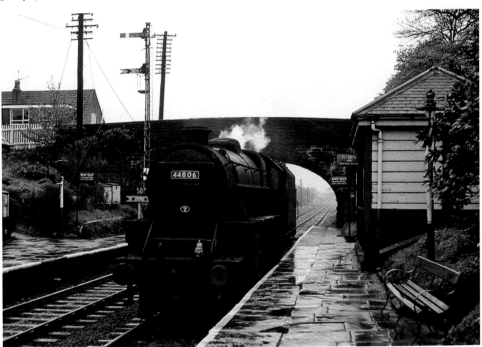

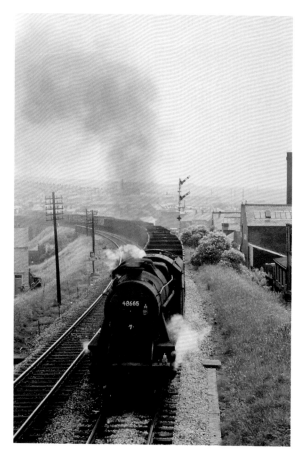

Left: 8F 48665 works hard as it climbs away from Accrington with eastbound coal empties on 13 July 1968.

Below: 8F 48400 is heading west and about to cross the viaduct over the town of Accrington with a very short freight on 13 July 1968. There are at least ten tall chimneys in this view; I wonder how many survive today.

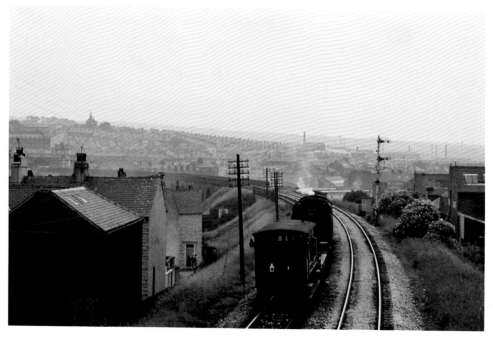

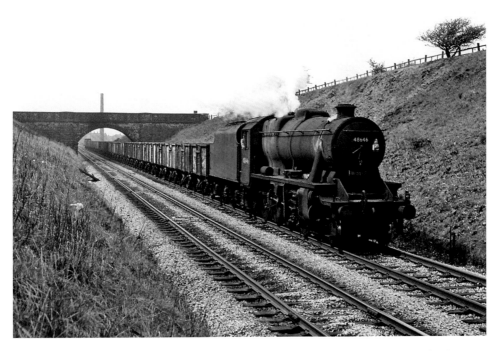

8F 48646 Approaches Rose Grove from the Accrington direction in May 1968 with a long train of coal empties bound for the Yorkshire collieries.

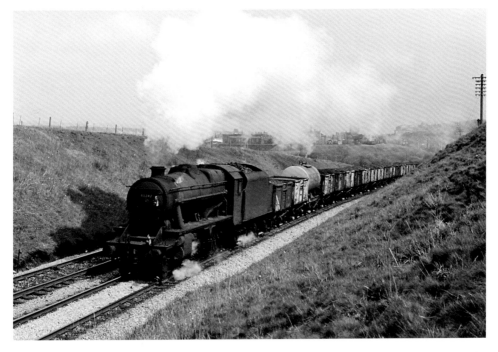

8F 48247 leaves Rose Grove in May 1968 with a westbound coal train. The loco depot at Rose Grove can be seen in the background.

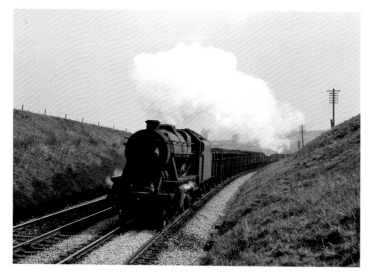

8F 48348 climbs out of
Rose Grove in May 1968
with another westbound
coal train.

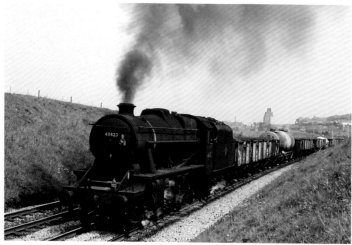

8F 48423 heads
towards Preston out
of Rose Grove with a
westbound freight.

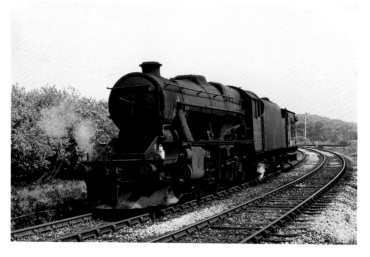

8F 48257 is waiting for
the signal to clear so
that it can run into Rose
Grove with its brake van
after taking a load of
coal down the branch to
Padiham Power Station.

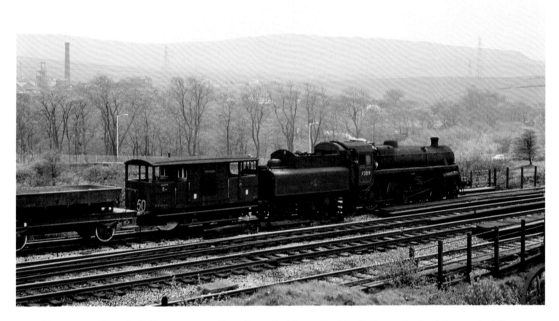

Two views of Standard Class 4 75019 at Rose Grove in May 1968 with a ballast train that it has worked from the quarry at Rylstone. The first picture shows it waiting in the loop, and the second starting away heading in the direction of Accrington.

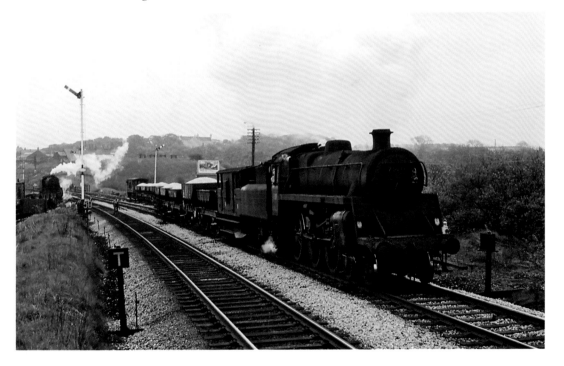

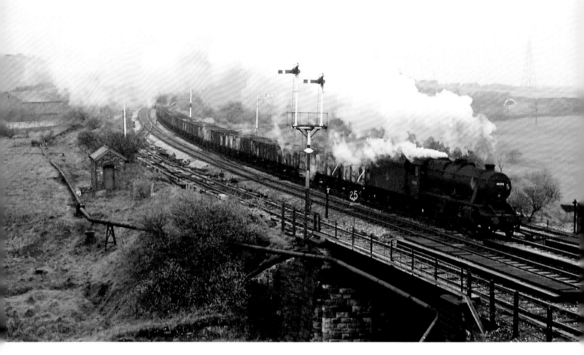

Two shots of 8F 48393 passing through Rose Grove in May 1968 with a lengthy rake of eastbound coal empties, crossing the Leeds & Liverpool Canal, passing the loco sheds, and heading towards the station.

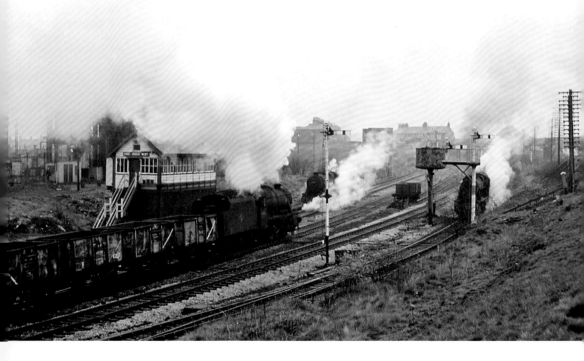

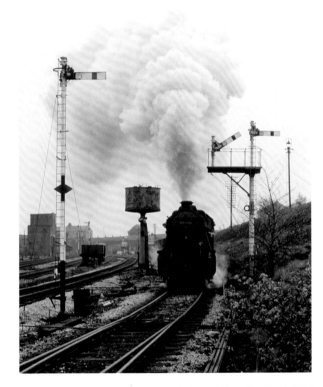

8F 48730 gets underway and works hard in preparation for the climb out of Rose Grove in May 1968 with a westbound coal train.

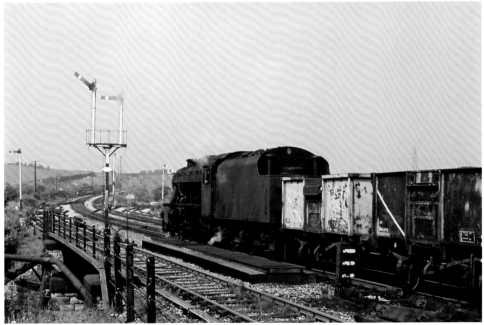

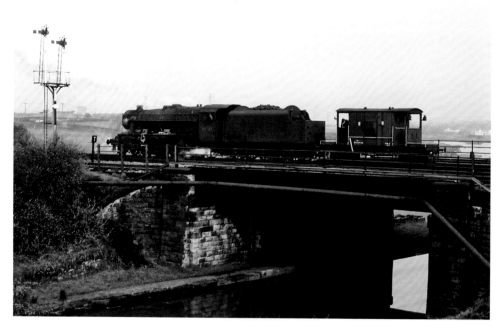

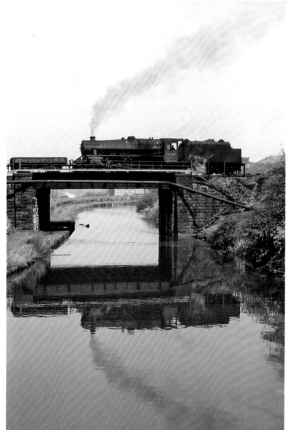

Above: 8F 48329 backs into Rose Grove in May 1968 with a brake van after taking a load of coal down the branch line to the power station at Padiham.

Left: Class 5 45447 is reflected in the Leeds & Liverpool Canal as it crosses the bridge at Rose Grove with a short engineer's train.

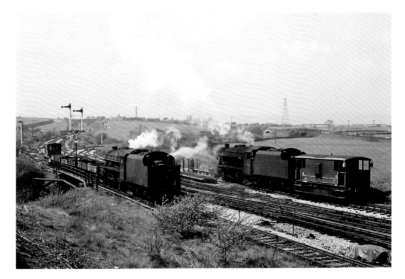

Class 5 45447 potters about with its engineer's train as 8F 48730 trundles past with a brake van after a trip to Padiham Power Station.

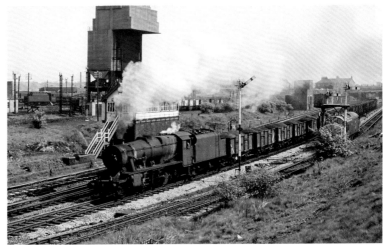

8F 48423 roars through Rose Grove with a westbound coal train while English Electric Type 3 D6710 lurks behind a bush.

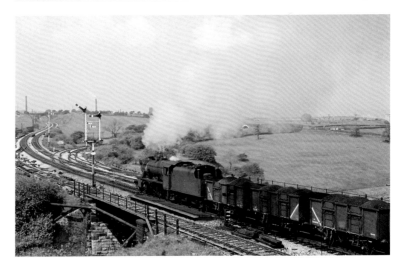

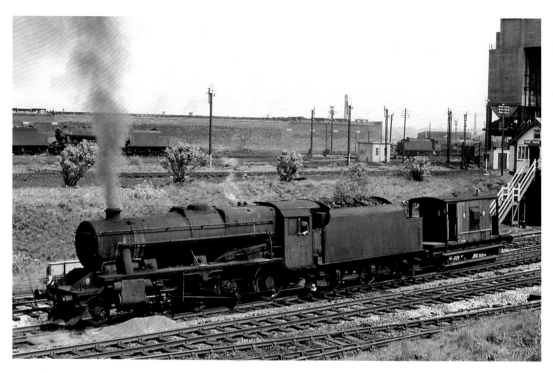

8F 48257 backs past towards the yard to leave its brake van after a trip to the power station at Padiham.

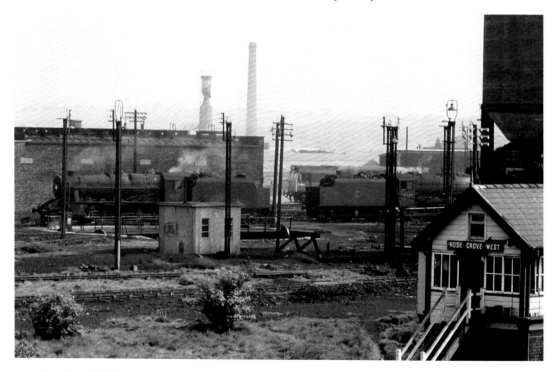

Rose Grove MPD as seen from the lines passing through on 13 July 1968 with an 8F on the turntable, as well as a Class 5 and Class 25 diesel outside the shed.

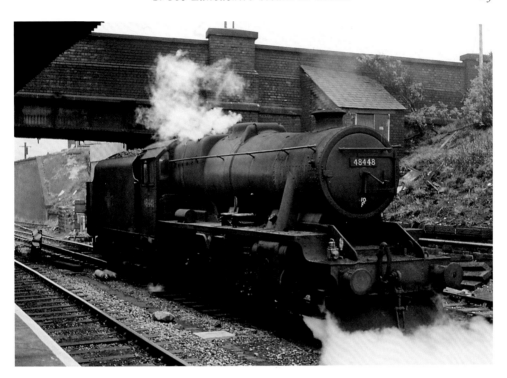

8F 48448 has just come off Rose Grove MPD and stands alongside the station, waiting to cross over to the yard and pick up a train.

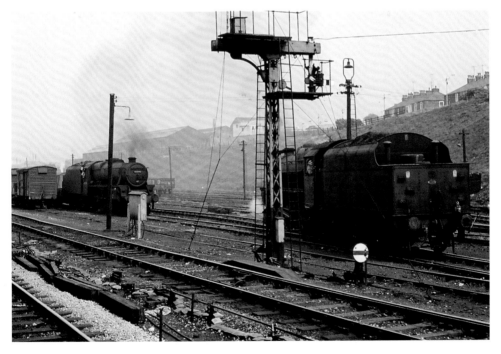

Two Class 5s are in the yard alongside Rose Grove station, making up trains that will head west towards Manchester and Preston.

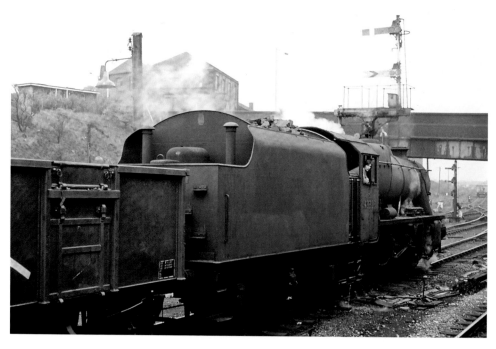

8F 48323 is waiting to start a westbound coal train out of Rose Grove yard in May 1968.

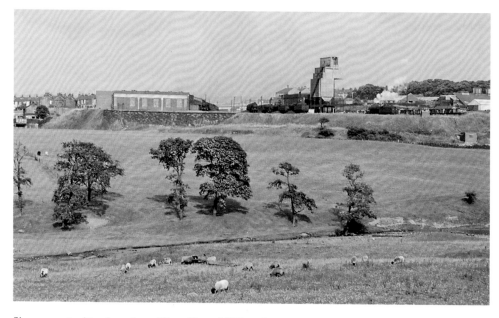

Sheep graze in this sylvan view of Rose Grove MPD, with its concrete coaling tower towering above all else. The photo was taken on 13 July 1968 from the Padiham branch, which closed in 1993 when Padiham Power Station was shut down. Much has changed in the forty-nine years since this photo was taken. Rose Grove shed closed with the end of steam on 3 August 1968, and the M65 motorway, opened in 1983, passes through towards the camera just about where the shed stood. The Leeds & Liverpool Canal still runs across the picture on a line just below the brick building to the right of this scene. Much of the sheds' water supply came from the canal.

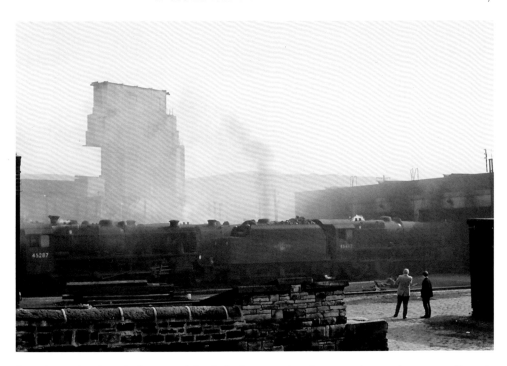

Considering that the end of steam, and the sheds closure, are less than a month away, the amount of locos in steam is quite remarkable. An enthusiast stands chatting with a young fireman as he takes in the atmosphere. Picture taken on 13 July 1968.

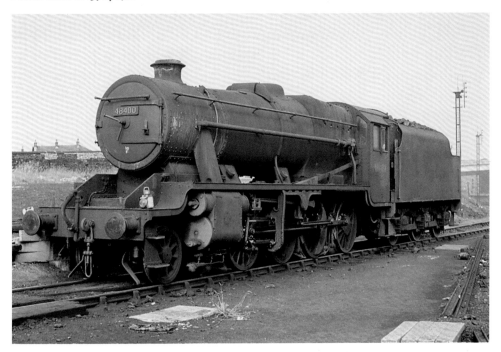

8F 48400 at the shed on 13 July 1968 in between duties. 48400 was built at Swindon in 1943 and was withdrawn at the end of steam 3 August 1968.

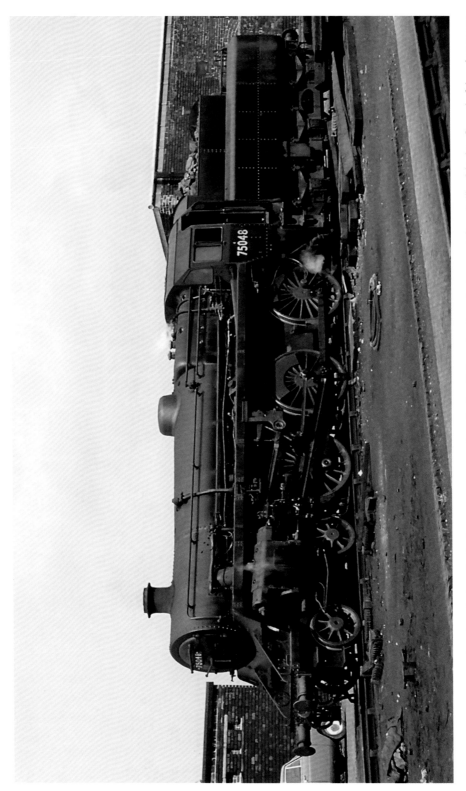

Standard 4 75048 is a visitor from Carnforth, and is looking very smart. 75048 survived until the end and was broken up at Campbell's of Airdrie. Several of these locos were kept for working ballast trains from Rylstone Quarry near Grassington to various destinations in the North and East Lancs area. Taken in May 1968.

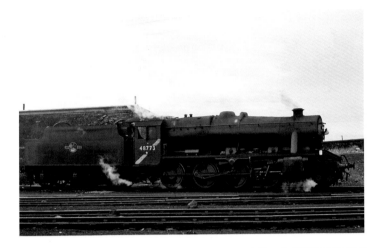

Three views of 8F 48773 on 13 July 1968. This loco was kept in smart condition by members of the Severn Valley Railway, who later purchased the loco when it was withdrawn from service. 48773 was built at North British in Glasgow in 1940.

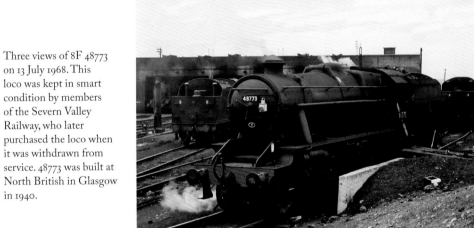

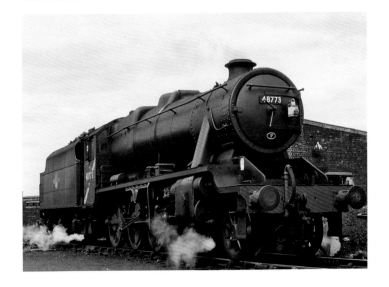

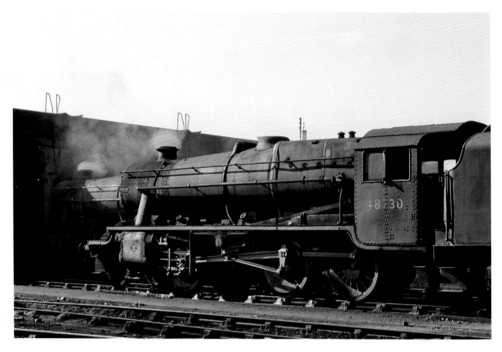

8F 48730 in May 1968. 48730 was built at Darlington in 1945 and lasted until the end of steam on 3 August 1968.

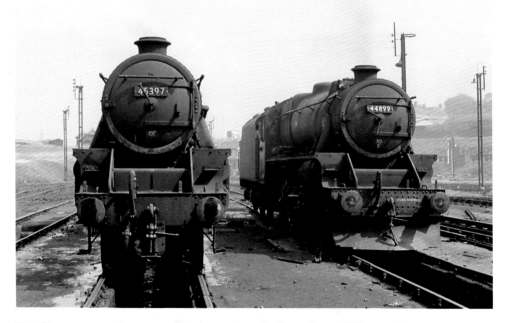

Two Class 5s, 45397 and 44899, stand at the eastern end of Rose Grove MPD on 13 July 1968. 44899 has a snowplough fitted and was at Carlisle Kingmoor until steam finished there at the end of 1967. 44899 was built at Crewe in 1945 and scrapped at Cohens of Kettering in early 1969. 45397 was built by Armstrong Whitworth in 1937 and survived to the end on 3 August 1968.

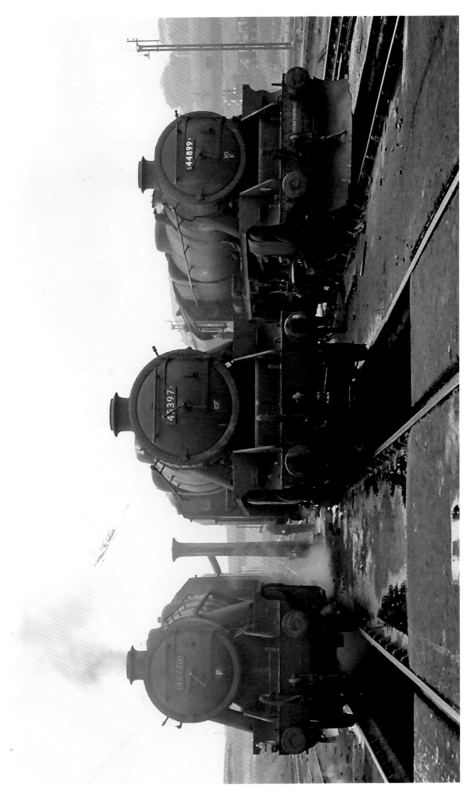

8F 48730 and Class 5s 45397 and 44899 make a nice lineup at the shed on 13 July 1968.

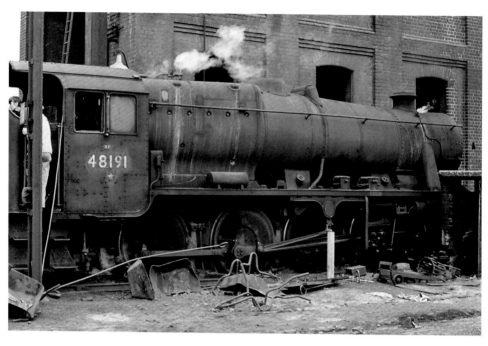

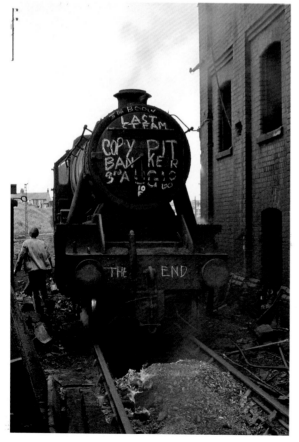

Sad scenes on the last day of steam on BR, as 8F 48191 stands over the ash pit at Rose Grove on 3 August 1968 and drops its fire for the very last time. It had done its last duty as bank engine for trains climbing up the hill from Todmorden to Copy Pit Summit. 48191 was built by North British in 1942 and scrapped in late 1968.

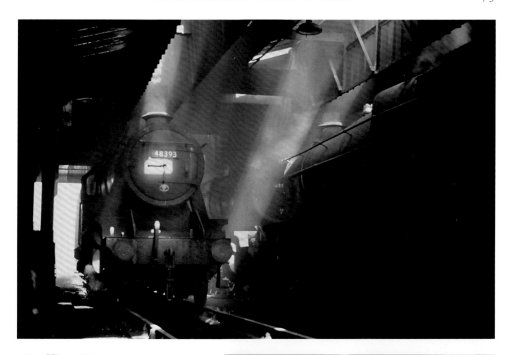

Above: Three 8Fs, 48393, 48493 and 48727, stand among the shafts of sunlight and smoke inside Rose Grove MPD on 13 July 1968 as they get up steam ready for the next duty.

Right: More sun and steam inside the shed, taken during the afternoon of 13 July 1968.

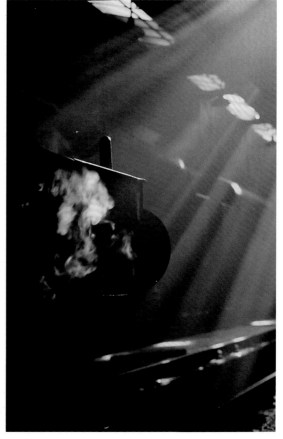

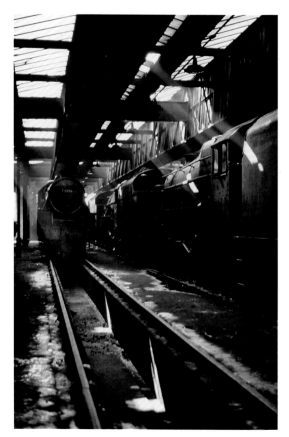

Left: Class 5 45096 and some sister locos stand in a less smoky part of Rose Grove MPD on 13 July 1968.

Below: 8F 48081 and Class 5 44898 have just been withdrawn from service and wait for their tenders to be emptied of coal on 13 July 1968.

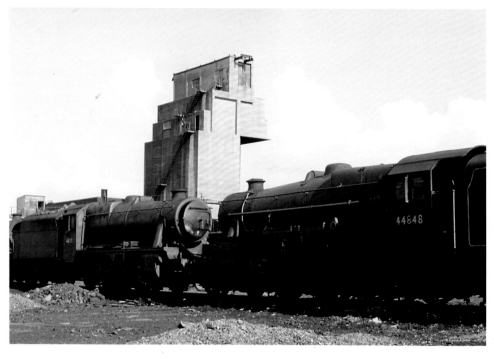

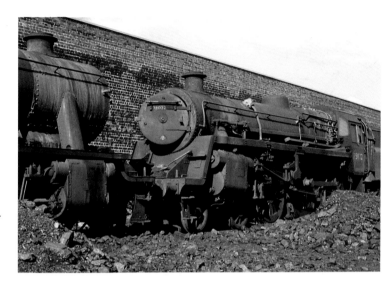

Standard Class 4 75032 is waiting to be towed to TW Ward's scrapyard at Beighton. 75032 was built at Swindon in 1953. May 1968.

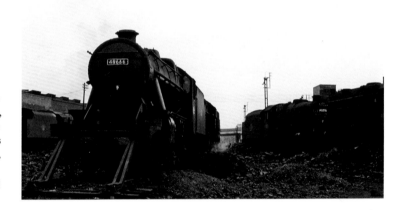

8F 48666 was built at Brighton in 1944 and, along with just about all the other residents at Rose Grove MPD, waits to make its last journey for scrapping on 3 August 1968.

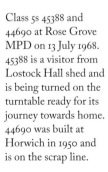

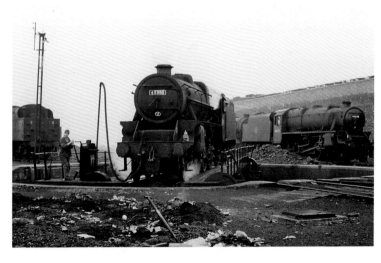

Class 5s 45388 and 44690 at Rose Grove MPD on 13 July 1968. 45388 is a visitor from Lostock Hall shed and is being turned on the turntable ready for its journey towards home. 44690 was built at Horwich in 1950 and is on the scrap line.

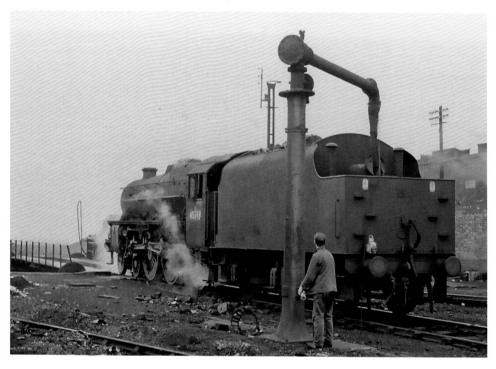

Having been turned, 45388 takes water in readiness for its journey back to Preston with the evening parcels train from Colne.

Class 5 44848 was built at Crewe in 1944 and waits to make its last journey to Cohens yard at Kettering for scrapping. Taken in May 1968.

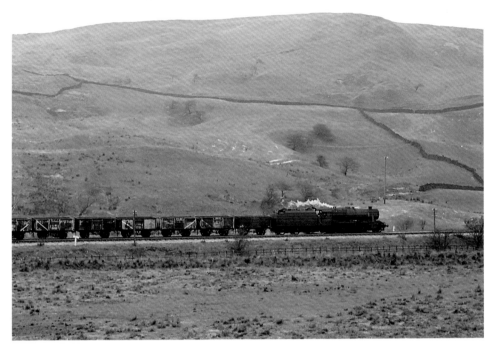

An 8F 2-8-0 has just crested the summit at Copy Pit and is cautiously making its way downhill towards Todmorden and the Yorkshire Pits with a train of coal empties in May 1968.

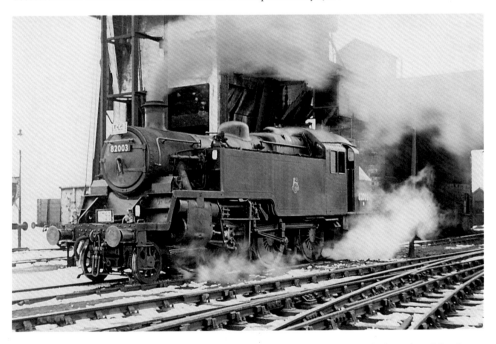

On 16 April 1966 the Locomotive Club of Great Britain ran the Cotton Spinner Railtour from Manchester Central for a tour that included Buxton and the Royton branch. Standard Class 3 82003 is seen here at Buxton MPD in very cold conditions.

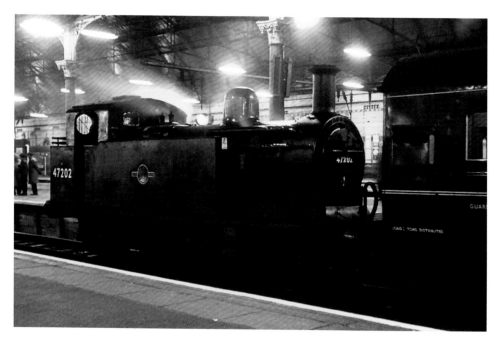

Ex-Midland Railway Class 3F 47202 is seen here at Manchester Piccadilly after working the Cotton Spinner Railtour with 82003 from Royton on 16 April 1966.

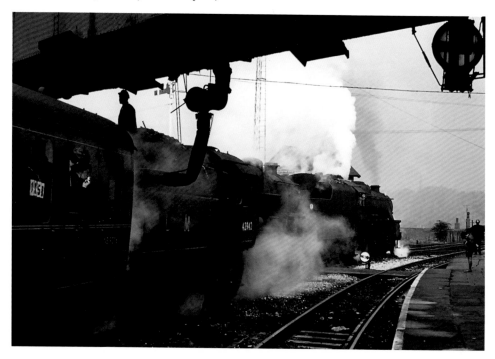

On 8 October 1966, the LCGB ran the Crab Commemorative Railtour from Liverpool to Goole, and Crab 42942 with Class 5 45336 is seen at the Bury line platform at Accrington, having come over the now-closed, steeply graded line via Ramsbottom from Manchester and Bury – part of which is now the East Lancashire Railway. The train is waiting to depart east towards Rose Grove, Todmorden, Wakefield and Goole.

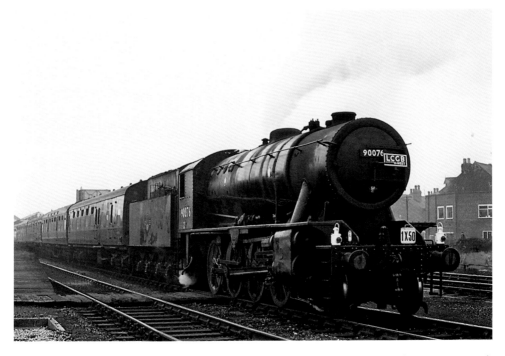

Although the next two photos were not taken in Lancashire the tour used engines that were very much part of the Lancashire scene, so they are included here. Later in the tour, WD 2-8-0 90076 took over from Wakefield Kirkgate as far as Goole and is seen here at Goole station.

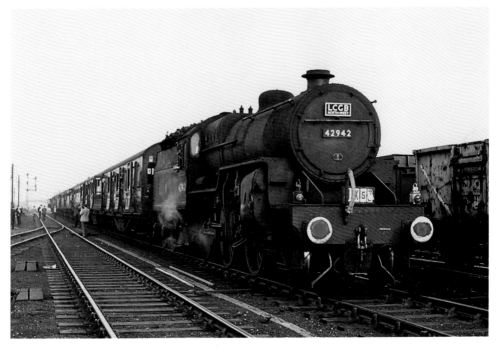

42942 came back on the train at Goole station and is seen here on the line outside Goole MPD, waiting while we visited the loco shed before heading back to Liverpool.

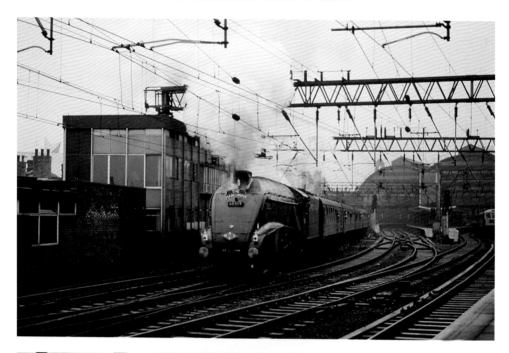

Above: A4 60019 *Bittern* is seen passing through Manchester Piccadilly station on the line from Oxford Road with the Lancs & Yorks Rambler/The Mancunian Railtour that ran from Leeds to Manchester via Lancaster and Preston on 25 November 1967.

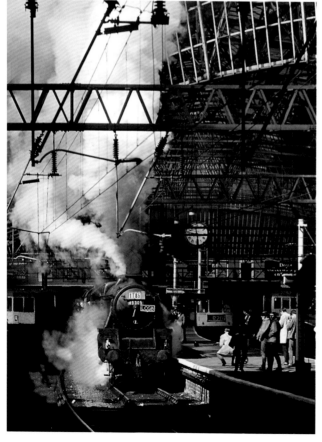

Left: Class 5 45305 is seen departing from Liverpool Lime Street station on 6 April 1968 with the LCGB Lancastrian Railtour, which ran over several branch lines in the Liverpool area.

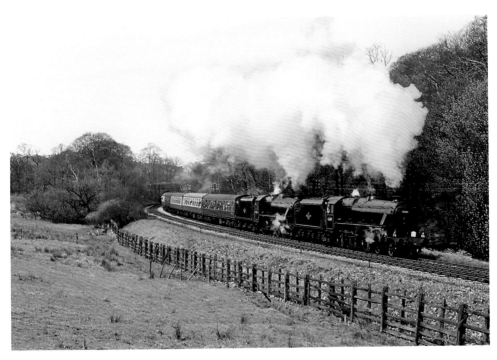

Class 5s 45110 and 44949 climb through Disley on 20 April 1968, heading for Buxton with the Severn Valley Railway Society and Manchester Rail Travel Society North West Tour, which was so popular a duplicate was run on the next Saturday.

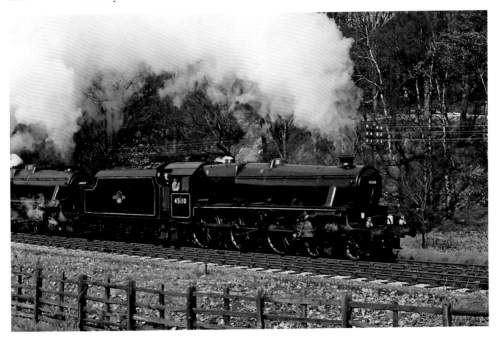

A close-up of 45110 at Disley on 20 April 1968. 45110 was built at Vulcan Foundry in 1935 and after withdrawal from service was preserved at the Severn Valley Railway. 45110 gained fame by hauling the last leg of the Fifteen Guinea Special – the last BR steam-hauled train – from Manchester to Liverpool on 11 August 1968.

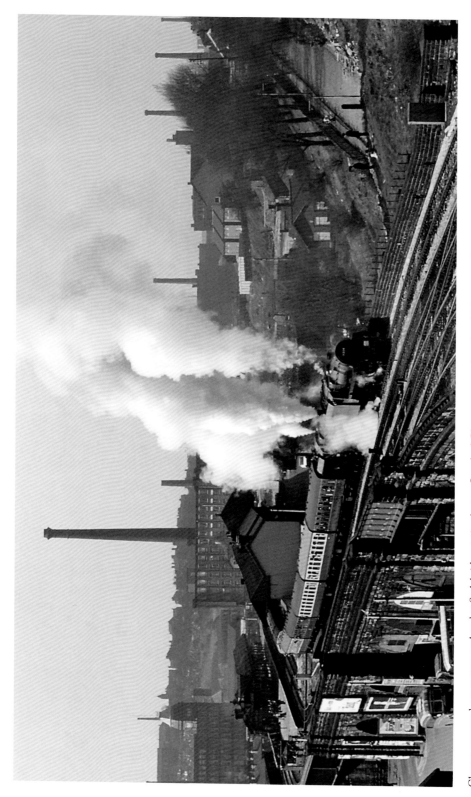

Class 5s 45110 and 44949 were replaced at Stalybridge station by two Standard Class 5s, 73134 and 73069, which are seen departing eastwards heading the special to Bolton. As with the pictures taken at Accrington, there are many chimneys and old mills to be seen in these two views, which are reminiscent of a Lowry painting. Do any remain today?

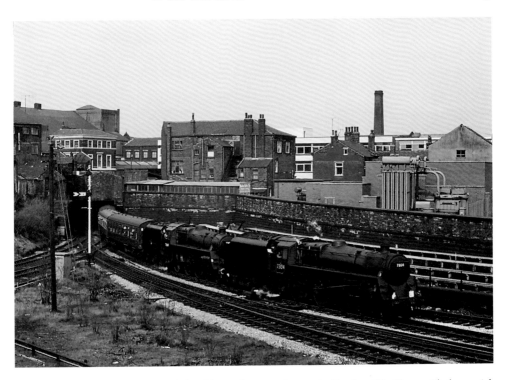

73134 and 73069 are seen arriving at Bolton Trinity Street station on the line from Blackburn with the special. The original station buildings at street level seen in the second picture were demolished when the station was rebuilt in 1980, but thankfully the clock tower was rebuilt next to the new station.

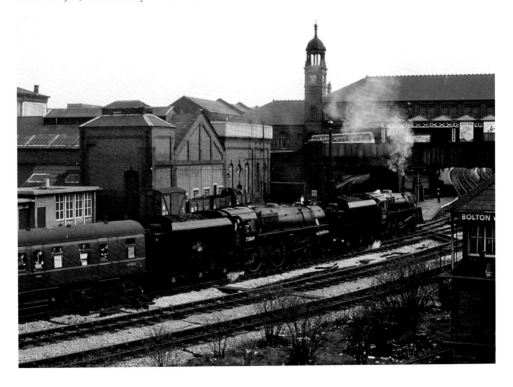

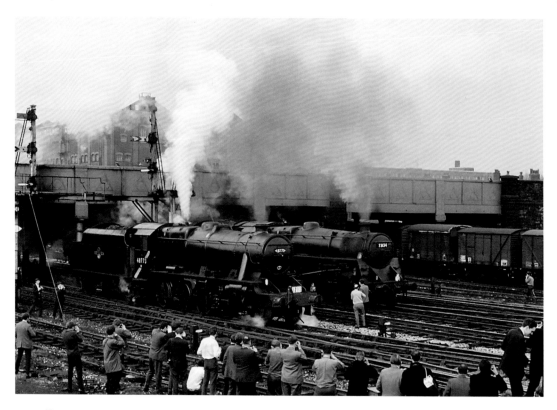

8F 48773 and 73134 are seen at south end of Bolton station amid scenes of mass trespass that would not be tolerated today as the crowds of photographers get their shots of 48773 taking over. It is seen departing for Stockport, where 92160 took the last leg to Liverpool.

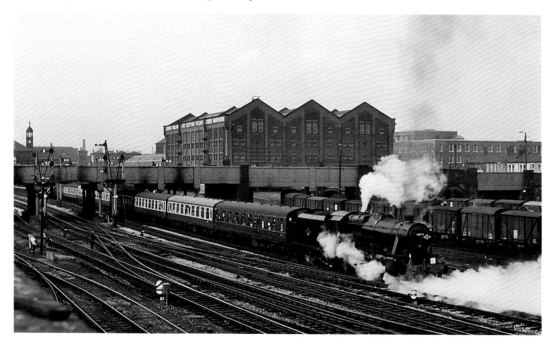

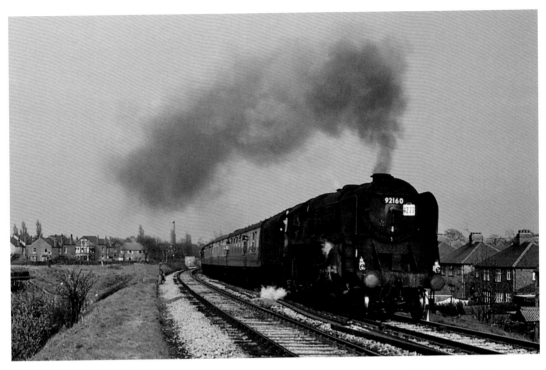

9F 92160 takes the LNWR route towards Warrington at Skelton Junction heading for Liverpool. 92160 was built at Crewe in 1957, withdrawn in June 1968, and cut up at Campbells of Airdrie in October 1968.

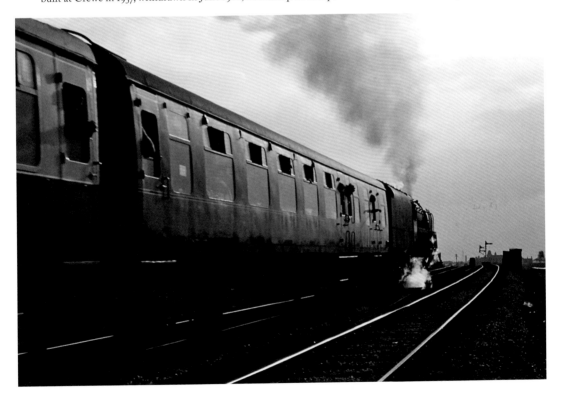

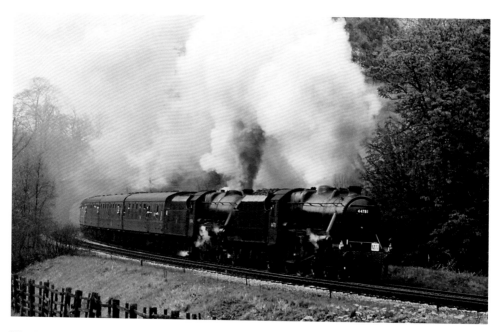

The following weeks' duplicate tour started behind Class 5s 44781 and 45046, seen here at Disley heading for Buxton on 27 April 1968. 44781 was going to be preserved as it was one of the locos that hauled the Fifteen Guinea Last Steam Special on 11 August 1968. It was used in the film *The Virgin Soldiers* and its role in the film involved a train wreck, which it survived, but BR wanted too much money for it to be towed away and the loco was cut up on-site. 45046 survived almost to the end of steam and was scrapped at Cohens of Kettering towards the end of 1968.

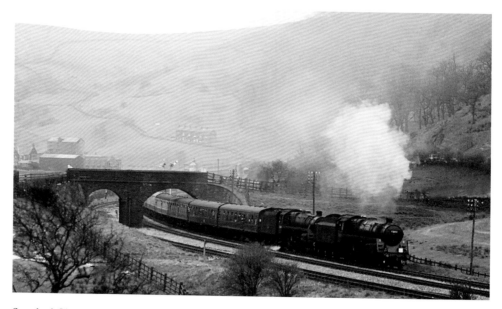

Standard Class 5s 73050 and 73069 are passing through Portsmouth on the climb to Copy Pit Summit on 27 April 1968. 73050 became quite famous when it worked on the Somerset & Dorset line in the late 1950s and early 1960s, and was preserved after withdrawal. It can now be seen at Wansford on the Nene Valley Railway. 73069 became the last of its type in service and lasted until the end of steam, but went for scrap.

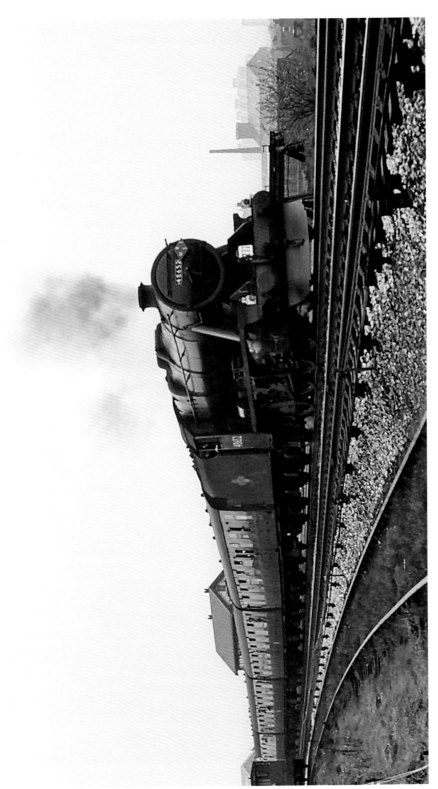

In this final shot of the special, 8F 48652 is leaving Rochdale heading for Oldham. I was following the train using train and bus and could not find a way to get from Rochdale in time to get a shot of the 9F on the last leg.

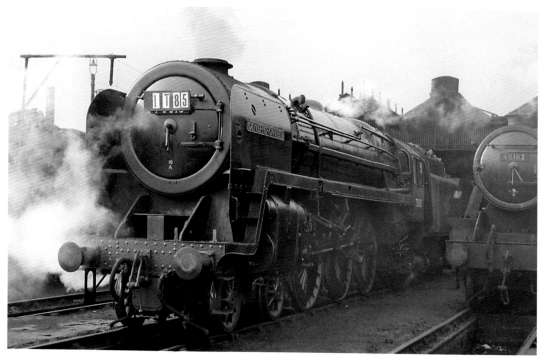

Britannia 70013 *Oliver Cromwell* is seen at Stockport Edgeley MPD on 28 April 1968 prior to working the Great Central Enterprises' North West Circular Railtour.

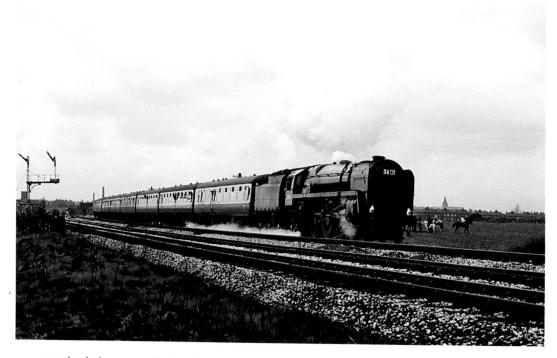

70013 heads the tour past Reddish Vale, heading for Manchester Victoria/Exchange stations.

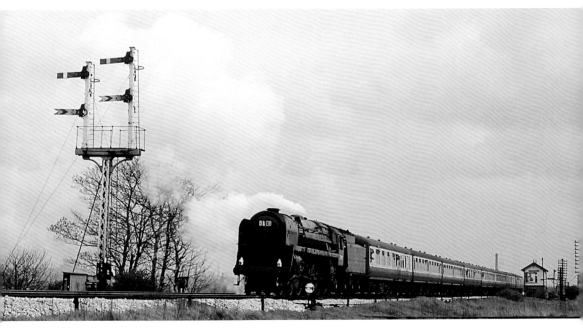

70013 passes Barton Moss signal box with the tour as it heads for Southport.

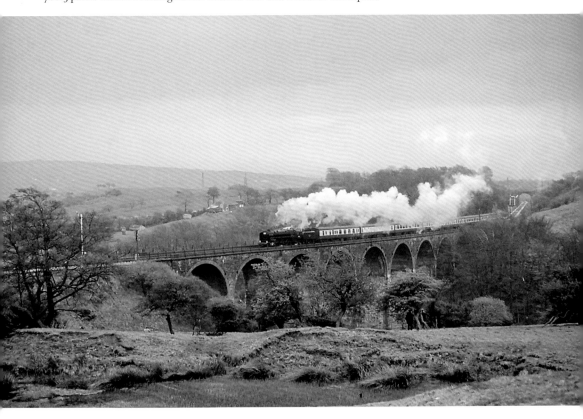

70013 crosses Entwistle Viaduct with the tour, heading for Blackburn.

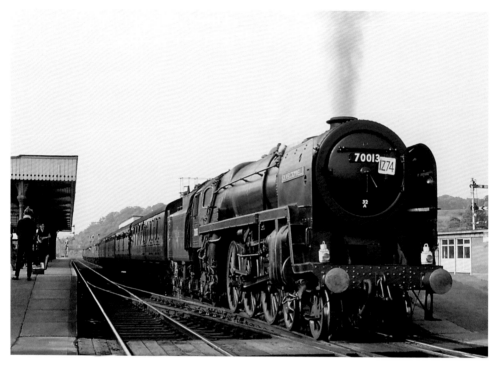

Although not strictly a Lancashire picture, this tour came to Manchester and shows 70013 *Oliver Cromwell* at Chesterfield station on 9 June 1968 with the Midland Lines Centenary tour, which was run by BR from St. Pancras to Manchester Victoria with 70013 from Derby to Manchester and back to Nottingham.

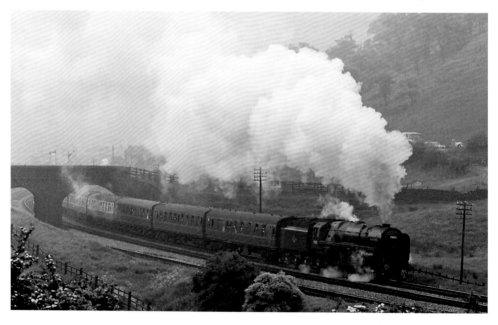

70013 *Oliver Cromwell* is seen here passing Portsmouth on the climb to Copy Pit Summit with the RCTS Dalesman No. 2 Railtour, making for Carnforth on 16 June 1968. Note the third coach, which was designed by Oliver Bulleid for the Southern Railway.

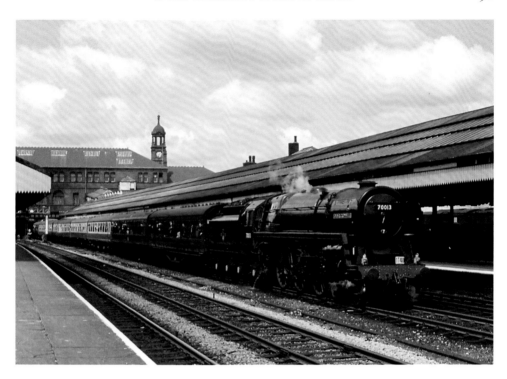

70013 *Oliver Cromwell* passes Bolton station on 21 July 1968 with the Roch Valley Railway Society Manchester–Southport Steam Excursion, heading towards Manchester.

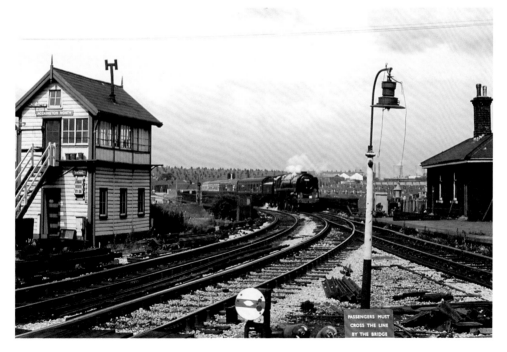

This second picture of 70013 shows the tour crossing the viaduct and approaching the east end of Accrington station on 21 July 1968, heading for Southport.

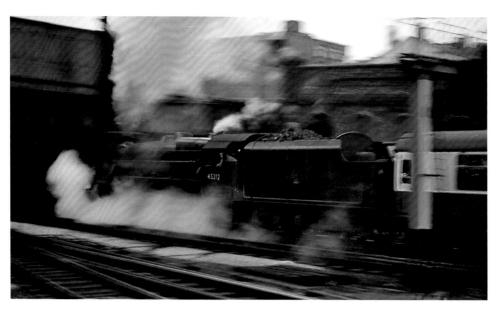

Class 5 45212 is departing from Preston station on 3 August 1968 with the through coaches from Euston, which formed the 20.50 Preston Blackpool train. This was the second to last regular steam hauled passenger train on BR, the last being the Preston to Liverpool Exchange later in the evening, which unfortunately I could not stay to see.

The last nine pictures in this book were taken on 4 August 1968, which was the day after the official end of steam on British railways. No fewer than six special trains criss-crossed Lancashire that day and such was the complexity of schedules that we decided not to try and chase them but to stay put in a place where most of them would pass at some time.

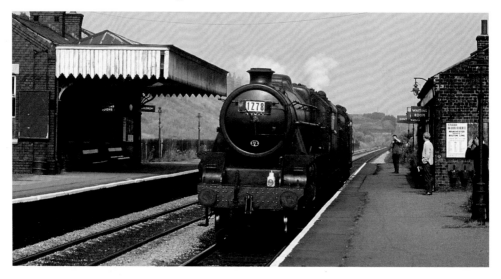

Class 5s 44894 and 44871 pass through Kearsley station on their way to Manchester Victoria to haul the SLS No. 1 tour. 44894 was built at Crewe in 1945. 44871 was one of the locos that hauled the Fifteen Guinea Special over the Settle & Carlisle line the next Sunday, 11 August 1968, and is currently preserved at the East Lancs Railway.

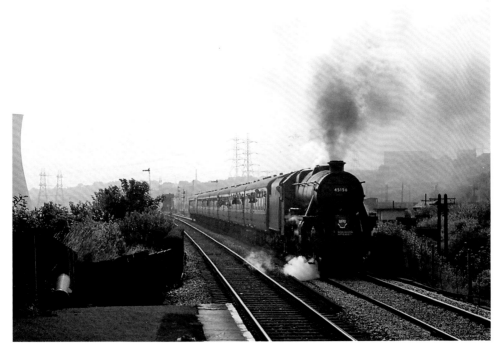

Class 5 45156 climbs through Kearsley station with the Great Central Enterprises tour, which it hauled from Stockport to Carnforth and back.

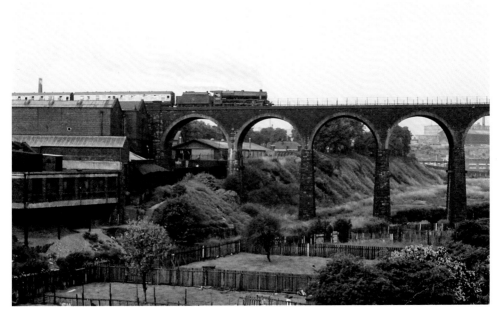

We managed to overtake 45156 and got to Bolton in time to get it crossing Astley Bridge Viaduct, which is on the line to Blackburn.

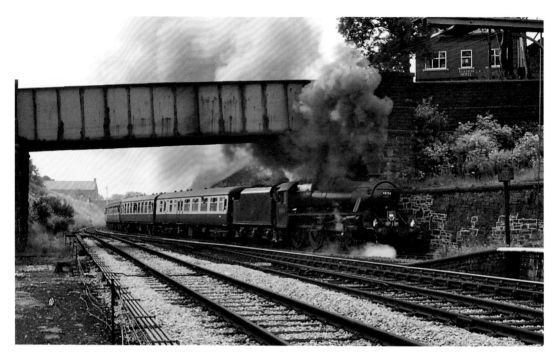

Another quick drive got us to Entwistle station, where we saw 45156 passing, and then decided to take up position by Entwistle Viaduct for most of the day.

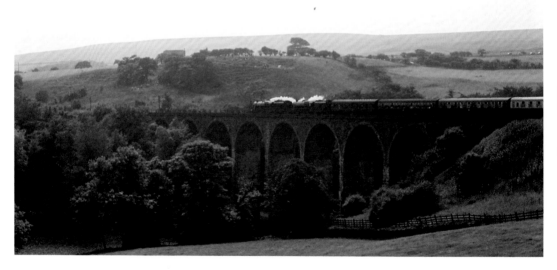

Class 5s 44894 and 44871 are the next to cross the viaduct at about 14.00 on their way to Wigan and Manchester with the SLS No. 1 tour.

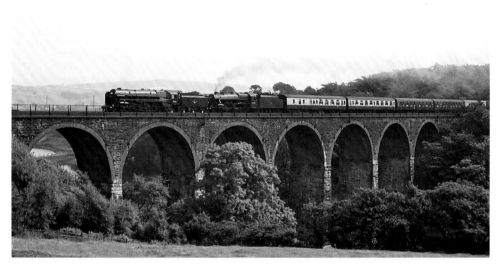

Britannia 70013 *Oliver Cromwell* and Class 5 44781 double-head the LCGB train across the Viaduct on their way from Manchester to Blackburn at about 14.50.

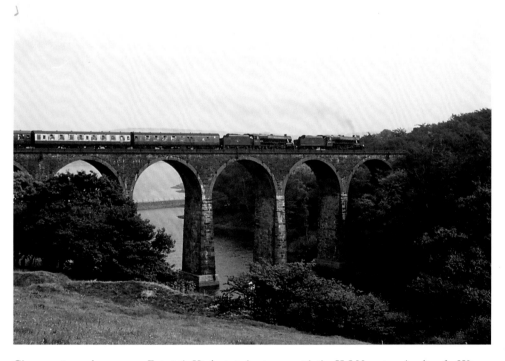

Class 5s 44874 and 45017 cross Entwistle Viaduct at about 15.40 with the SLS No. 2 tour, heading for Wigan, Rainhill and Manchester.

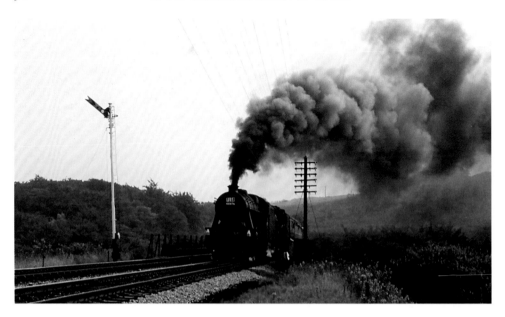

The RCTS tour behind 8F48476 and Standard 5 73069 has just crossed Entwistle Viaduct and are approaching Entwistle Station at about 16.00 – some two and half hours late. We had given up on seeing this train and we were making our way back to the station where we had parked the car when we heard it approaching, and just had time to get a quick shot. This special eventually got back to Euston four and a half hours late.

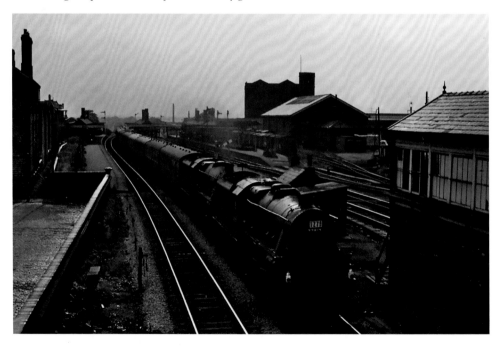

We decided to visit Patricroft shed on the way home and were lucky to see 44874/45017 passing through Patricroft station at about 18.00 with the SLS No. 2 tour. So ended a very sad and somewhat chaotic day. Luckily, the weather was sunny and warm all day and the photos came out pretty well. We were all out again the next weekend to see the Fifteen Guinea Special over the Settle & Carlisle line and those pictures can be seen in a later volume.